To Mary and Michael
With Best Wi.

C000056862

GREAT RAILWAY

LONDON
TO OXFORD
AND
LONDON
TO CAMBRIDGE

ROGER MASON

AMBERLEY

First published 2022

Amberley Publishing
The Hill, Stroud
Gloucestershire, GL5 4EP

www.amberley-books.com

British Library Cataloguing in Publication Data.
A catalogue record for this book is available from the British Library.

ISBN: 978 1 4456 8764 3 (print)
ISBN: 978 1 4456 8765 0 (ebook)

Typesetting by SJmagic DESIGN SERVICES, India.
Printed in the UK.

Preface

This is my thirty-first book and the fourth in the Great Railway Journey series for Amberley Publishing. The others have been *London to Birmingham*, *London to Sheffield* and *The Chiltern Line to Birmingham*. I have greatly enjoyed writing them and I hope that this is apparent when this book and the others are read. The fifth book in the series will be *The Flying Scotsman Route to Edinburgh* and I am looking forward to that journey.

I have loved trains since my childhood and given a reasonable choice, which of course is by no means always the case, I do not understand why so many people prefer to take the car. I have never been addicted to technical matters concerning railways, but I love looking out of train windows at the fascinating things that can be seen. Most of what is described in this book can be seen from the train, but just a few are close by.

I have travelled both of the lines featured and visited everything described in the book. I have also visited other sites not suitable for inclusion. Despite the temptation I have not raided the internet for any of the photographs. I must thank my wife for the ones at Southall, Audley End and Duxford Chapel, and I must thank passers-by for the ones of Brunel's statue at Paddington Station and myself at Bethnal Green. I took all the others.

My thanks are due to my wife, Dorothy, for her invaluable help with the photographs, to Naina Mistry who helped with the manuscript and to my wife's cousin, Geoff Wright, who read it, spotted a few mistakes and made helpful suggestions.

Finally, my best wishes for reading this book. I hope that you enjoy it and perhaps decide to visit some of the places mentioned.

Roger Mason

Contents

LONDON TO OXFORD

Paddington Station

As Julie Andrews memorably sang in *The Sound of Music* 'Let's start at the very beginning, a very good place to start'. The journey to Oxford commences at one of London's most famous railway stations. It has a long, interesting and distinguished history and will always be linked with the name of the great Victorian engineer Isambard Kingdom Brunel.

Brunel was only twenty-seven when he was appointed to be the engineer for the planned railway from London to Bristol. He surveyed the entire route himself and the result was a masterpiece. Controversially the Great Western adopted his decision to make the railway broad gauge. The rails were 7 feet 0.25 inches apart, whereas almost all of the country's other railways were standard gauge, namely 4 feet 8.5 inches apart. Broad gauge rails ran into and out of Paddington until GWR switched to standard gauge in 1892.

The first part of the railway opened on the 4 June 1838 and it ran from London to Taplow, which is after Slough and just before Maidenhead. A temporary terminus station was opened the same day at Bishop's Bridge Road in London, and this was extended in 1850. After this Brunel was commissioned by the directors of the Great Western Railway to build a new and bigger station at Praed Street. The railway was also known as GWR, Great Western and affectionately as God's Wonderful Railway. The Bishop's Bridge Road areas became a goods depot and the new station linked it with Praed Street in Paddington. The Great Western Royal Hotel in Praed Street was built at the same time, and it is the subject of the next chapter of this book.

Brunel relished the task and set about designing what he intended to be London's greatest railway terminus. Everything that he planned was always ambitious and this frequently had cost implications. Consequently the GWR directors persuaded him to economise and modify his plans. Nevertheless, he still designed and constructed a great station.

The Crystal Palace had been built for the Great Exhibition in London's Hyde Park in 1851, and this iconic structure was an inspiration for Brunel. He built what at that time was the largest railway station in the world. The roof's main span was 102 feet and there were two other spans of 70 feet and 68 feet respectively. The new station was opened on 29 May 1854, just a few days before HRH the Prince Consort opened the nearby Great Western Royal Hotel.

The new station had four platforms accommodating the two lines coming in and out. This was adequate at the time but in due course increasing usage necessitated an increase

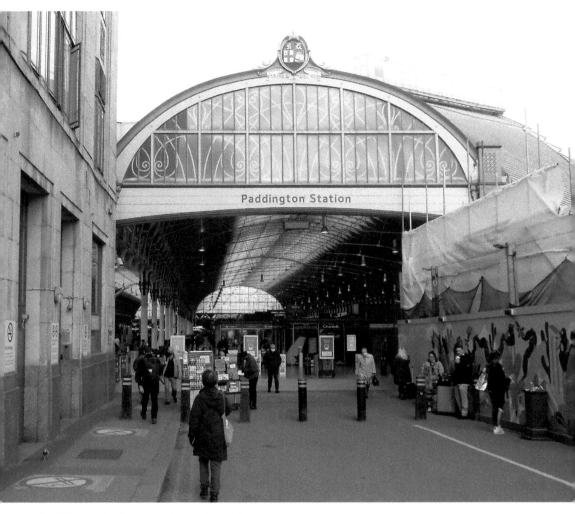

Paddington Station viewed from Praed Street.

in its capacity. In the 1870s both the number of platforms and the numbers of lines were doubled. A further platform was added in 1878 and two more in 1885. Brunel's original roof structure remained untouched. There was another increase in the First World War and an additional span was built, and there was another enlargement in the early 1930s.

The size of the concourse was increased in 1970 and at the same time the ticket office was rebuilt. Happily, and unlike Euston, the work was done sensitively. There was further refurbishment in the 1990s and Brunel's original glass roof was replaced with polycarbonate glazing. The station now has fourteen platforms.

For reasons unknown to me the covered area between the platforms and the hotel is known as the Lawn. As you would expect a visit to it can be a significant shopping experience, and there are many eating and drinking possibilities as well. Unusually, in my experience, there are men's and women's showers, as well as toilets. The cost is £5 per visit.

Despite its fame Paddington is by no means the most used railway terminus in London. The Covid-19 pandemic greatly reduced the number of people using trains and some of its

effects are ongoing. The following, measured by annual entries and exits, were the eight most used stations in 2017/18:

Waterloo	94,345,000
Victoria	74,955,000
Liverpool Street	66,967,000
London Bridge	48,453,000
Euston	44,746,000
Paddington	36,578,000
St Pancras	34,622,000
King's Cross	33,905,000

Paddington is the terminus of the Great Western main line, and commuter and regional services. It is also the terminus for the Heathrow Express and TFL services to Heathrow Airport and Reading. There are two separate tube stations, and it is interesting to note that it was the terminus for the world's first underground railway.

It is worth looking for the two statues. One of them is a life-sized tribute to a seated Isambard Kingdom Brunel. The sculptor was John Doubleday and it is located between Platforms 8 and 9. The photograph shows the writer posing with it. The other is a war memorial positioned next to Platform 1. This is dedicated to the employees of the Great Western Railway who died in the First World War, but a plaque underneath extends it to the dead of the Second World War as well. It is a large bronze statue of a soldier reading a letter from home. The sculptor was Charles Sargent Jagger and it was unveiled by Viscount Churchill on Armistice Day in 1922.

I hope that it is acceptable to include a personal childhood reminiscence concerning the station. My parents had lived for a few years in Plymouth and my father had fond memories of the station, and in particular of the Cornish Riviera Express. This was, and to some extent still is, one of Britain's most famous named trains, and it left Paddington at 10.30 a.m. for Plymouth and then on to Penzance.

My father took me to the station for the first time when I was about six. Before leaving home we set his watch to exactly the correct time and he told me that we would see the Cornish Riviera leave at 10.30, and that it would do so on time to the second. This did not happen and in fact it left half an hour late. We never knew the reason but my father was very disappointed. It is only fair to add that three years later we had a family holiday in Plymouth and we travelled there on the Cornish Riviera. It was a great experience, and the train ran exactly on time for the whole journey.

Around the same time Paddington Station featured in my education. A schoolmaster explained what a clerihew was. As you will know it is a four-line poem where the first two lines rhyme and the last two lines rhyme. The first line consists of a person's name and the poem is usually whimsical, absurd or derogatory. The example he gave us was:

Isambard Kingdom Brunel
Created an awful smell
He left it to the nation
At Paddington Station

The viewpoint is of course nonsense. The great man left no malodorous legacy whatsoever. I detected no such problem when I researched this book.

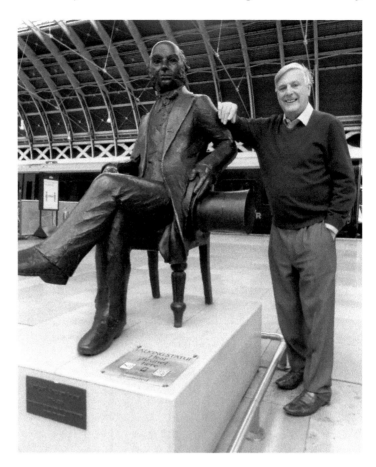

The writer with
Brunel's statue.

Finally, it would be remiss not to end this chapter without mentioning Paddington Bear. This is the lovable creature from 'Darkest Peru' that features in more than twenty children's books, and stars in feature films. Like me he is fond of marmalade and he was found at Paddington Station by the Brown family. That accounts for his name.

Thank you Paddington! You have given a lot of pleasure to a lot of people.

Hilton Hotel, Paddington: Formerly the Great Western Royal Hotel

In the nineteenth century most of the great Victorian railway companies built impressive hotels at or close to their London termini, and also at some of their locations around the country. Many of them are still standing, though frequently with different names. The financial reason for building the hotels is obvious. As Jane Austin, who wrote *Pride and Prejudice*, might have put it 'A tired traveller at the beginning or end of a railway journey must be in want of a hotel'.

The St Pancras Renaissance Hotel is held by many to be the jewel in the crown and it is reviewed in my book *Great Railways Journeys: London to Sheffield*. This was built for the Midland Railway Company and opened by Queen Victoria in 1873. The renowned architect was Sir Gilbert Scott. Another great hotel and the last to be built is the Landmark London Hotel. This was built for the Great Central Railway and it opened in 1899. It is reviewed in my book *Great Railways Journeys: The Chiltern Line to Birmingham*.

The Great Western Railway was no exception, though its London hotel was mainly financed by some of its directors rather than by the company itself. It was opened by HRH The Prince Consort on 9 June 1854. It was sold to the Great Western Railway in 1896. When it opened it had 115 bedrooms, mainly five floors but seven floors in the turret towers. It is now Grade II listed and it was designed by the architect Philip Charles Hardwick. It was built by Holland, Hansen & Cubitts.

The hotel company was chaired by Brunel from 1855 until his death in 1859 at the age of only fifty-three. How on earth did he find the time and how much of it was he able to give to the hotel? He was a workaholic and phenomenally busy. Apart from anything else his ship *The Great Eastern* was launched with great difficulty in 1858. It is believed that overwork and stress were contributory factors in his untimely death.

When the decision was taken to build the hotel the directors of the railway company, and Brunel in particular, had the dream that a passenger sleeping in it would take a Great Western train to Wales, then a Great Western ship to New York. The ship part of the dream did not come to pass.

As is inevitable with a hotel of this age and standing there are a wealth of stories about it and its guests. Available space limits the stories to just one, especially as the guest has an extraordinarily long name. It is Richard Temple-Nugent-Bridges-Chandos-Grenville, 2nd Duke of Buckingham and Chandos, KG, GCH, PC, FSA. He inherited Stowe in Buckinghamshire together with its extensive estate and a lot of money, which he managed to spend with great abandon. Among other things he loved hosting extravagant house parties for prominent people. It was at one of these at Stowe that Queen Victoria first met Benjamin Disraeli. The Duke was a former cabinet minister and in 1847 he managed to go bankrupt with debts of over a million pounds. It was a phenomenal amount of money at that time. He died in the hotel on 29 July 1861.

In the 1930s the hotel was remodelled by architect Percy Emerson Culverhouse and after the Second World War it passed to British Railways when the Great Western was nationalised. Then in 1983 it was sold to the private sector. After other ownership it reopened as a Hilton Hotel in 2001. In view of its heritage it is a shame that the Great Western name was dropped, but there is a plaque at the front giving the former name.

The Hilton is a four-star hotel in Praed Street, Paddington, and as can be seen from the photograph it is a long building. In fact it separates the street from the concourse of the station.

What follows is a personal point of view and you might or might not agree, though I have found that many people do. We might call it artistic licence but the term writer's licence seems more appropriate. During my visit to the hotel I noticed that barriers had been placed in the road on both sides. They had the effect of widening the pavements and reducing the space available for vehicles. The extra space for pedestrians was not necessary because the width of the pavement was already adequate. The effect on the road traffic was severe. Buses were stuck holding up the traffic. Taxis were stationary and

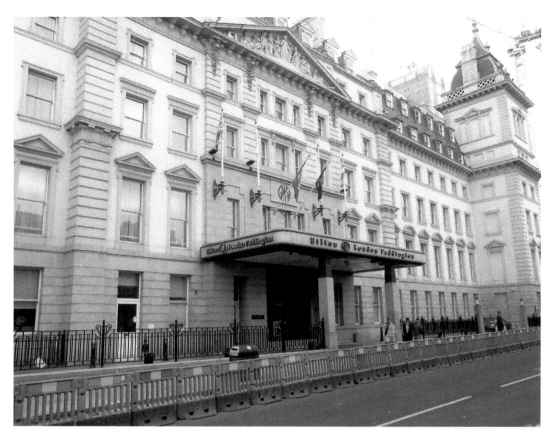

The Hilton Hotel, Paddington.

frustrated passengers sat watching the charges tick up on the meter. The fumes from the immobile vehicles were polluting the atmosphere, which was the opposite of what was intended.

It is the same in all of London. New cycle lanes hardly used, unnecessarily widened pavements and general obstructions for traffic are all being put in place. Furthermore, the congestion charge has been raised. It is happening in many other places too and all comes at a cost. It is not apparent that this is the way to increase the sum of human happiness.

Ladbroke Grove: Site of the 1999 Crash

Before reading this section of the book please take time to consider that rail transport is exceedingly safe. In recent years the number of passenger deaths have been very low and in some years there have been none at all. When you board a train it is a virtual certainty that you will reach your destination safely. This is true when I write these words but let us hope that it is true when you read them. I think that it will be.

Having made this clear an account follows of the disaster on 5 October 1999. It happened only two years after the crash at Southall a few miles further up the line. This is described in the next section of the book. The Ladbroke Grove crash was just 2 miles out of Paddington Station and it is sometimes described as the Paddington crash. The location can be identified by the gasometer, which can be seen close to the track on the right side of the train. This is large and is shown in the photograph.

The lines out of Paddington as far as Ladbroke Grove Junction were signalled to allow trains to run over them in either direction, a situation that, of course, necessitates considerable operational care. Shortly after 8.00 a.m. a three-car Thames Class 165 Turbo service bound for Bedwyn in Wiltshire ran past a red signal, and the point settings beyond it allowed the train to run on a section of track cleared for a train travelling towards Paddington. The awful result was a head on collision with a First Great Western Class 125 High Speed Train from Cheltenham. The combined speed of the impact was 130 mph.

The result of this was dreadful. Thirty-one people were killed including the drivers of both trains. In addition a further 227 were admitted to hospital and 296 were treated with minor injuries at the scene of the accident. Having escaped from the wreckage some heroic souls returned to the carriages to help those less fortunate. Valuable assistance included help for people in burning carriages. The nearby Sainsbury's supermarket served as an initial location for treatment of the injured.

The immediate consequence of the collision was bad enough, but it was made worse by fires in three of the carriages, one of them very severe. A column of black smoke was visible over a significant part of West London. The fires were probably caused by the friction of steel on the HST rubbing against the aluminium of the Turbo unit. This would have been enough to ignite the spilt diesel fuel. Parts of the wreckage were buried under 3 feet of ash and debris, and some of the dead could only be identified by their dental records.

The immediate cause of the crash was the driver of the Turbo train, Michael Hodder, passing signal S109, which showed a red aspect. He should have been prepared for the red because the previous signal had shown a warning yellow aspect. Driver Hodder was thirty-one and new to the railways. Until recently he had served in the Royal Navy and had only finished his training thirteen days previously. Sadly Hodder did not live to give his account of what had happened. Although blame appears to lie with him, there were a number of important other factors.

Signal S109 was known to be a problem and it had been passed at danger eight times in the previous six years. It was one of twenty-two in the country with a very poor SPAD (Signal Passed at Danger) record. It was badly cited and Bristol HST trains had been rerouted so as not to pass it. The bright morning sun was low and behind the driver. This could well have distorted his view and the colour of the signal.

There had been deficiencies in training Driver Hodder, who was new to the railways. Before privatisation British Railways training was longer and would have taken account of his inexperience. Furthermore, he would not have been allowed to drive over this very difficult track until he had spent some time on other routes. In February 1999 an external audit of the training had stated 'The trainers did not appear to be following the training course syllabus and supporting notes as they considered these to be not fit for purpose with inappropriate time allowances for some sessions'.

Afterwards Hodder's trainer said that he felt that 'I was not there to teach _ _ _ the routes. I was totally to teach _ _ _ how to drive a Turbo'. Details of signals that had been repeatedly passed at danger should have been given to the trainers and passed on to the

trainees, but this was not done. Driver Hodder's trainer was not aware that Signal S109 was a multi-SPAD signal.

There was a standing requirement that the relevant signalman should respond as soon as he became aware that a signal at danger had been passed. He should have immediately set signals at danger and sent an emergency signal to the driver by secure cab radio. This was not done until the train was 200 yards past the signal. The signalman's belief, confirmed by their immediate manager, was that they should wait to see if the train stopped before trying to contact the driver. The signalman in question had not been trained in the use of Cab Secure Radio.

The Turbo train had been fitted with Automatic Warning System (AWS) apparatus. This required the driver to acknowledge a warning every time that the train approached a signal not at green. It had not been fitted with Automatic Train Protection System (ATPS), which would have automatically applied the brakes if the train passed a red signal. National adaptation of this had been abandoned because it was felt that the safety benefits did not justify the cost. Partly as a result of the inquiry into the crash ATPS and subsequent systems have now been installed throughout Britain's railways. In 2003 the Rail Safety and Standards Board was set up and in 2005 this was followed by the

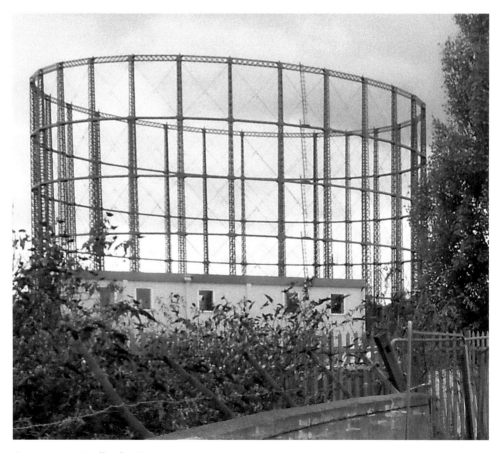

Gasometer at Ladbroke Grove.

Rail Accident Investigation Branch. This is separate and in addition to the HM Railway Inspectorate.

Subsequent to the crash Thames Trains pleaded guilty to two health and safety offences. It was ordered to pay a fine of £2 million and costs of £75,000. Network Rail was fined £4 million and had to pay costs of £225,000.

Driver Hodder's widow discovered a week after the crash that she was pregnant with their third child. She did not think kindly of Network Rail and after the court case criticised them for 'vilifying' her husband. She said 'he was a victim as much as anyone else. The bosses at Network Rail, or Railtrack as it was then, had known for years that the signal outside Paddington station was dangerous, yet they did nothing about it. He was led into a rat-trap and there was no way out'.

A small memorial garden has been constructed partially overlooking the crash site. It is accessible from Sainsbury's car park and contains a stone recording of the names of the thirty-one people who died. I visited it shortly after the twenty first anniversary of the crash and noticed that, poignantly, a number of wreaths and floral tributes had been left at the foot of it.

Southall and the Southall Crash

Southall station dates back to 1839 and is one of the very oldest on the line. It is 9 miles from Paddington and beyond Hanwell. The photograph shows the writer standing on one of the platforms next to a board identifying the station. As well as giving the information in English it does so in a foreign language. In case it is not familiar, which may well be the case, you should know that this is Gurmukhi. This is Sikh script used in the Punjabi region of India.

This is an extremely strong indication of the ethnic make-up of the Southall residents. Before exploring this it is worth saying that to the best of my knowledge there are only five other stations in England that are labelled in this way. For St Pancras International, Ebbsfleet and Ashford it is French. Hereford, which is managed by Transport for Wales, has it in Welsh. For Wallsend it is Latin. I think that this is showing off, but it is because it is close to Segededunum Roman fort.

The concentration of people whose ethnicities are other than white British is one of the highest in the country, perhaps the very highest in the country. The 2011 census put the population at 69,857 and 28,018 of them lived in the Southall Green and Southall Broadway wards. 60.1 per cent of the combined total of the two wards were not born in the European Union. The ethnic breakdown was:

76.1% Asian
9.6% Black
7.5% White
6.8% Other

It is perhaps not surprising that Southall acquired the nickname 'Little India' and that it is a major centre of South Asian culture. The residents are more religious than anywhere else in London. The same census put their affiliations as:

35.4% Sikhism
24.9% Islam
18.6% Hinduism
12.9% Christianity

Only 2 per cent professed no faith at all.

Many residents have contributed much to Asian culture. Two names particularly caught my eye. One was Kuljit Bhamra MBE, who was and is a record producer, composer and musician. The other was Channi Singh OBE, who became known as the 'godfather of bhangra music in the West'.

A name that may not be familiar but deserves to be is Brian Gibbons. For his bravery in 1958 he was awarded the George Medal, which is Britain's highest award for gallantry not in the face of the enemy where the services were not so outstanding as to merit the George Cross. He was aged only fourteen at the time.

A cargo plane not carrying passengers crashed shortly after taking off from Heathrow, the reason being a failure caused by poor maintenance. The crew of three plus four people on the ground were killed. Brian Gibbons was in bed in one of the affected houses that caught fire and his five-year-old cousin was in the same room. Despite smoke and fire he tried to get them both down the stairs but had to turn back. Due to the smoke he lost his cousin who had slipped to the floor. He turned back and stumbled over him. He managed to get his cousin out of the second floor window and the cousin was caught by people standing outside. He then got out himself and his fall was broken by someone outside. He suffered considerable burns and his bravery was extraordinary. He deserves a mention in this book.

The heading of this chapter includes reference to the Southall rail crash and this tragic event took place in the early afternoon of 19 September 1997. The location was after Southall station and after the arm of the Grand Union Canal, which is the subject of the next chapter.

The tragedy involved two trains. One was a Great Western Trains Intercity 225 High Speed Train (HST) heading to Paddington from Swansea. It had 212 passengers on board. The other was an EWS freight train with twenty bogie hopper waggons. This was coming away from London and needed to cross the HST's track at Southall East Junction.

The HST's Automatic Warning System (AWS) had been defective and it was switched off. Had it been working it would have been given the driver an audible warning that the signal was at caution and red had been passed. Had it been working the disaster would probably have been averted.

The HST approached the junction at a speed of 125 mph. Driver Harrison did not see the two signals at caution because, he later said, he was bending down to pick up his bag. When he stood up he was horrified to see that the train had almost reached the red signal and that the hopper train was moving into the junction. He immediately applied maximum braking power but there was no chance of stopping his train in time.

The driver of the hopper train accelerated to try and get out of the way, but there was not time. Even if he had succeeded there would presumably still have been a crash, but not such a serious one. This was because the points would probably still have been set against the HST. The High Speed Train hit the hoppers at a speed of about 70 mph. Seven passengers were killed and sixteen were trapped under the wreckage. A total of 139 passengers were injured. A fire caused by the accident was quickly extinguished.

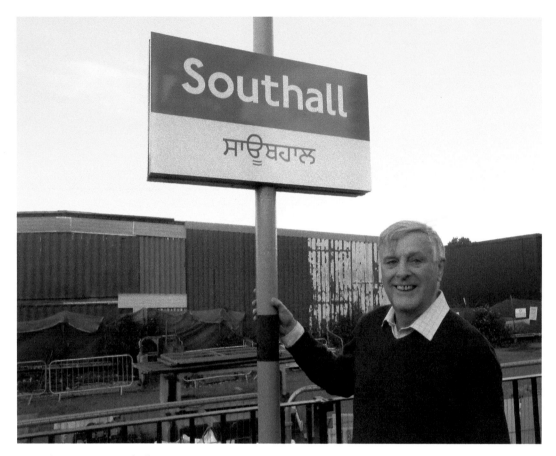

The writer at Southall Station.

The driver of the HST, Larry Harrison, had been driving since 1975. He was charged with manslaughter, but the prosecution offered no evidence and a verdict of not guilty was formally recorded. Great Western Trains was also charged with manslaughter. As with the driver no evidence was offered and a formal verdict of not guilty was recorded. The company was, however, fined the then record sum of £1.5 million after pleading guilty to a lesser charge.

The subsequent enquiry did not criticise the signalman or the driver of the hopper train. It did, though, heavily criticise Great Western Trains and made a number of strong recommendations. A main one was that the Automatic Warning System should be considered essential to the train running, and that if it was for some reason not operative the train should be withdrawn.

Automatic Train Protection was a system that continually checked that the speed of the train was compatible with the speed permitted by the signalling, and applied the brakes if it was not. The enquiry recommended that its use should be extended and that where it was already installed should be maintained in a fully operational state.

This is the second serious rail crash described in the first four chapters of this book. As stated in the Ladbroke Grove chapter, rail travel is exceptionally safe. In many years not a single passenger life is lost on Britain's railways.

The Paddington Arm of the Grand Union Canal

The photograph was taken in the outskirts of West London shortly after Southall Station. It shows the Paddington Arm of the Grand Union Canal and the bridge over which the train passes.

The Paddington Arm is 13.5 miles long and it connects the Paddington basin with the main line of the Grand Union at Bull's Bridge in Hayes. It is fed with water from the Brent reservoir and it has no locks. This means that it provides valuable water for the main line of the canal as well as the arm.

The arm provides a very attractive green corridor through north-west and west London. This is greatly appreciated by wildlife, walkers and boaters. It passes factories, warehouses and other indicators of the area's industrial past. A particularly interesting site is the remaining evidence of Kensal Rise cemetery. At one time coffins for it arrived by narrowboat.

The bridge is the only opportunity to see this canal from the train, but the Paddington Basin at which it ends is very close to Paddington Station. This and a short part of the arm is worth a look if you have a few minutes to spare. The canal is adjacent to the station and

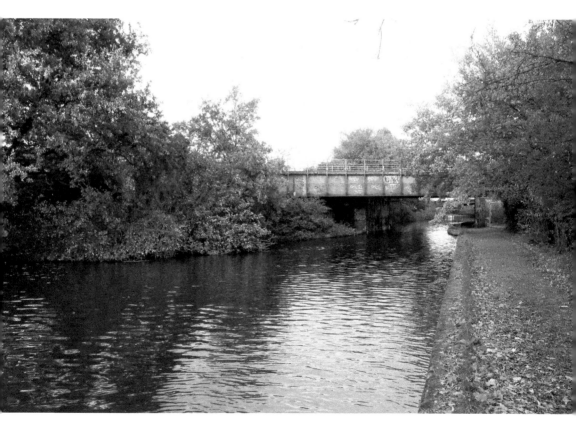

Railway bridge over the Paddington Arm.

it is signposted from it. The basin is impressive and features cafés, shops, boats for hire and other things.

An Act of Parliament passed in 1795 authorised the building of the arm and it was opened on 10 July 1801. Then as now estimating the size of crowds was notoriously difficult, but it was estimated that around 20,000 people watched. Building the arm in six years seems quite an achievement, although the absence of locks would have helped. It was all done by navvies using shovels and wheelbarrows. The term navvy is derived from the word 'navigator'. They built the railways as well.

It may seem hard to believe but in 1801 Paddington was still a village. London was rapidly expanding but there were still fields between Paddington and it. An amusing contemporary rhyme emphasised the difference in size between the two places. William Pitt the younger was one of Britain's great Prime Ministers and he achieved the position at age the of twenty-four. He was Prime Minister from 1783 to 1801 and again from 1804 to 1806. Henry Addington held the office between the two terms. He had merit but he was not in the same league as Pitt. George Canning, the witty future Prime Minister, remarked: 'Pitt is to Addington as London is to Paddington.'

A short distance from the Paddington Basin the arm links to Regent's Canal at Little Venice. This was completed in 1820 and it joins the River Thames at Limehouse. It is stretching the imagination almost to breaking point but the combination of the Paddington Arm and the Regent's Canal might be likened to the canal equivalent of London's vehicular North Circular Road of a later age.

Slough

Slough is shortly after the village of Iver. It is 18 miles from Paddington and the quickest trains reach it in fourteen minutes.

The photograph is of Slough bus station, which can very easily be seen from the left side of the train. It is in fact directly opposite the station's main entrance and just a hundred yards away. Perhaps I have led a sheltered life but it is not like any other bus station that I have seen. It opened in 2011 and was a key feature in the rebuilding the town centre. Only part of it can be seen from the train. It has been described as a sort of sea creature covered in aluminium shingles, and organic deconstructavist building of curving walls and undulating roof lines. It is controversial, but it is probably true to say that most people like it and I am one of them.

The name Slough means soil and it was first recorded in 1195 as 'S/o'. It was historically part of Buckinghamshire but it was transferred into Berkshire in the 1974 local government reorganisation. The town expanded very considerably from the 1920s onwards and in 2018 the population was 164,000. Like Southall it is racially diverse, though not to the same extent. According to the 2011 census 45.7 per cent of the population was white and 39.7 per cent was Asian. Immigration from Poland has been significant.

Slough Trading Estate is the main reason for the expansion and the ethnic diversity of its inhabitants. It is owned by Segro PLC (formerly Slough Estates PLC) and is believed to be the largest industrial estate in single ownership in Europe. It covers no fewer than 486 acres. Founded in 1920, it was in an expanding and relatively prosperous town needing workers. Its employers attracted distressed job seekers from around Britain and especially

from Wales. In more recent times it has attracted immigrants looking for work, which accounts for the ethnic diversity already mentioned. Until 1973 the estate had a railway line, and it is worth mentioning that its heat and power is generated by burning waste.

Slough is sometimes considered not an attractive place and it is frequently derided. It is perhaps not a coincidence that the very successful comedy programme *The Office* starring Ricky Gervais was set there. A poem by the future poet laureate John Betjeman is often quoted. It has the title *Slough* and was written in 1937. It expressed his condemnatory view about destruction of the countryside caused by what he considered to be ugly urban expansion. The often quoted first verse reads:

> Come friendly bombs and fall on Slough
> It isn't fit for humans now
> There isn't grass to graze a cow
> Swarm over death

There are ten vitriolic verses in all. Betjeman came to regret having written the poem because Slough was bombed in the Second World War and people were killed. On the centenary of Betjeman's birth his daughter presented Slough's then mayor with a book of his poems. She had inscribed it with the words 'We love Slough'.

Although many people hold the view that Slough is not the most pleasing of towns, it is hard to deny that it is close to some beautiful scenery and interesting places. Readers of a certain age may recall that Christine Keeler was brought up in the nearby village of Wraysbury. She achieved fame, or perhaps notoriety is a better word, due to her central role in the Profumo Affair in 1963. Her childhood home was two converted railway carriages with no heating and no hot water.

The nearby village of Stoke Poges is both beautiful and interesting. It contains Stoke Park, a private five-star sporting and leisure estate, and its luxurious mansion is set in 300 acres. It has been the setting for many events and films, most notably part of the James Bond film *Goldfinger*. It is where Bond, played by the late Sean Connery, defeats his furious adversary in a game of golf.

Impressive as this undoubtedly is the village is probably best known for one of the most famous and best-loved poems in the English language. This is Thomas Gray's 'Elegy written in a Country Churchyard', written in 1750. It is extremely long and the famous first verse reads:

> The curfew tolls the knell of parting day,
> The lowing herd winds slowly o'er the lea,
> The ploughman homeward plods his weary way,
> And leaves the world to darkness and to me.

The country churchyard in question belongs to St Giles' Church in Stoke Poges. Writing these words bring back fond childhood memories. I recall sitting with my father on the churchyard wall. It was an overcast November day and we talked about the poem and the circumstances in which it was written. My father recited some of the verses and then we went to a football match.

Windsor Castle is 2 miles south of Windsor on the left side of the line, and Eton College is slightly closer. A shuttle rail service runs from Slough Station to Windsor and Eton Central

Station, which is located directly opposite the castle. The line was built in 1849 so that the Great Western Railway could take Queen Victoria to her castle. I tried desperately hard to see Windsor Castle from the London to Oxford train and I persuaded myself that I may have seen the flagpole. Perhaps I did but perhaps I did not.

Windsor and its castle is indelibly linked to the country's royal family and in 1917 King George V adopted the name Windsor as its surname. His reason was that the previous Germanic name was an embarrassment during a war with Germany. It risked making him unpopular or even stoking the fires of republicanism. His cousin, Emperor Wilhelm II of Germany, was not noted for his sense of humour, but when he heard of this he remarked that he was looking forward to attending a performance of Shakespeare's play *The Merry Wives of Saxe-Coburg-Gotha.*

At the time of writing Eton College, which I did not attend, has provided twenty of the country's prime ministers. The list includes five of the last thirteen (Eden, MacMillan, Douglas-Home, Cameron and Johnson). As with Stoke Poges I have a happy memory.

In my late teens I took a German au pair for a most enjoyable day in Windsor and Eton. As we looked at Eton College I told her about the prime ministers, and that including Eden himself ten of his eighteen strong first cabinet had been educated there. I later found that my companion had written to her mother and told her that she had been out with a boy who had gone to the same school as the prime minister and half the cabinet.

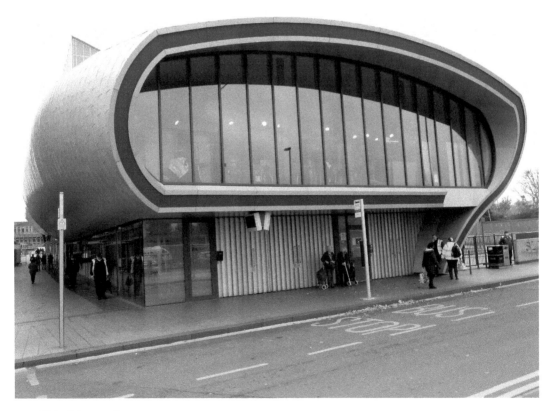

Slough bus station.

Burnham

Burnham is a large, pleasant and prosperous village quickly reached after leaving Slough Station. The 2011 census recorded its population as 11,630. Burnham's railway station is actually in western Slough and the tentacles of Slough Trading Estate reach almost to it. The destruction of countryside that this caused was in John Betjeman's mind in 1937 when he called for the friendly bombs. The story of his poem is told in the last chapter. The village has a long history. It was mentioned in the 1086 Domesday Book and in 1287 it was granted a royal charter and the right to hold an annual fair.

The photograph is of the village parish church on the right side of the train. It is the Church of St Peter and its website describes it as being 'Eucharistically centred in the liberal Catholic tradition'. It also stresses that music plays a major part in the services, and that the church has a talented organist, a well-led choir, a keynotes music group and hand bell groups. Church historians would be interested to know that the first church building on the site was probably built by the Romans and that the Saxons replaced it in about the year 700. It is believed that work on the present building was started in the reign of King Stephen (1135–54). A major restoration started in 1863.

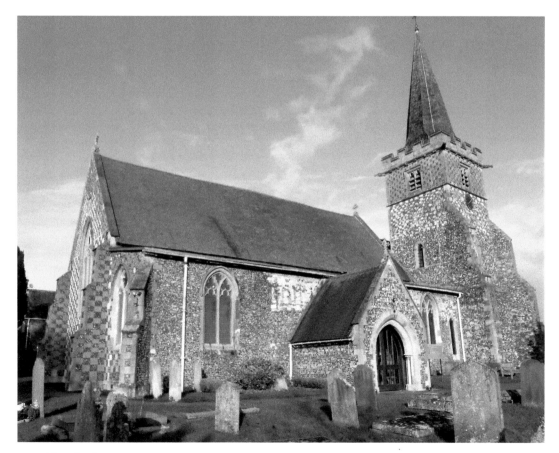

Church of St Peter.

Like Slough, Burnham is very close to some exceptional countryside, and in particular to Burnham Beeches. This covers 925 acres and really is an area of great natural beauty. I first heard of it from my mother. She was brought up in High Wycombe and as a child she was taken there on Sunday school outings. As the name suggests it is largely beech woodland, and it is rich in wildlife. The site is protected as a national nature reserve and as a Special Area of Conservation. The southern part is owned by the Corporation of London.

Dorneywood House is very close to Burnham. In 1947 this was given to the National Trust by Lord Courtauld-Thompson, and it is a grace and favour country house for the use of a senior member of the government. The Prime Minister of the day decides which minister has the use of it, and it is not unknown for behind the scenes lobbying or even squabbling to take place. In practice it is often the Chancellor of the Exchequer. The estate consists of the house and 250 acres of parkland, woodland and farmland. The National Trust opens the grounds to the public on selected days in the summer.

Taplow and the Chiltern Hundreds

Taplow is the south-westernmost settlement in Buckinghamshire, and Taplow Station is reached not long after Burnham. It serves a small and pleasant village to the north of it – so on the right side of the train. It is close to the River Thames with the town of Maidenhead being on the opposite side.

The Great Western Railway reached Taplow before the bridge over the Thames was completed, so for a short time Taplow was the line from Paddington's western terminus. The first station was constructed of wood and was given the name Maidenhead Bridge. The first train arrived on 4 June 1838, but the terminus moved westward over the river when the bridge was opened just over a year later.

The present station took the name Taplow and it opened it 1872. It is, perhaps surprisingly, rather large and grand for such a small village, but there is a reason for this. A number of GWR's significant shareholders lived nearby.

Taplow, like Slough and Burnham, is near some gorgeous countryside, and it is worth mentioning that it is close to Cliveden. This is now owned by the National Trust and Cliveden house is a luxury hotel. In 1961 it was owned by Lord Astor and it was there that Christine Keeler met John Profumo. She was swimming in the nude at the time.

The photograph is taken from Taplow Station looking to the left side. It is not a great view but the point is that it is within the Chiltern Hundreds. The line runs through the three hundreds that are used by Members of Parliament wishing to resign from the House of Commons.

Since 1624, death, disqualification and expulsion have been the only means by which a MP's seat may be vacated during the lifetime of a Parliament. An MP may not just resign his or her seat, so it has to be disqualification. An MP accepting the position of Crown Steward and Bailiff of the three Chiltern Hundreds of Stoke, Desborough and Burnham ceases to be an MP. Holding both positions simultaneously is not permitted.

An MP applies for the position. The application is considered by the Chancellor of the Exchequer, who could, in theory at least, say no. However, this has not happened since 1842. As soon as the application is accepted, the applicant ceases to be an MP. He or she then resigns from the Chiltern Hundreds, leaving the position vacant for the next applicant.

The position of Crown Steward and Bailiff of the Manor of Northstead is used in the same way. The positions are sinecures and carry no rights or responsibilities.

'Hundreds' date back to Saxon and Norman times and were administered by an elder. Later, a steward and bailiff was appointed by the Crown. They were divisions of English counties that could raise a hundred fighting men for the service of the monarch. The position of steward and bailiff was a legal one, answerable to the King or Queen, and the duties were to maintain law and order in the designated area. By the reign of Elizabeth I the duties were redundant because they had been taken over by Justices of the Peace, Sheriffs and Lords Lieutenant. By the seventeenth century certain Crown Stewards and Bailiffs still existed, but they had no powers and no duties.

As you gaze out of the window you may perhaps experience feelings of pride at the splendid peculiarities of what the Duke of Wellington once called 'our matchless constitution', which, until 1832, allowed a very small number of electors to choose Members of Parliament. Some of them voted in so-called rotten boroughs, the rottenest of all being Old Sarum, which sent two MPs to Westminster. It was controlled by just one man and at one time one of the borough's representatives was Prime Minister William Pitt the Elder. One likes to think that were he to be with us today, the Duke would see things differently. On the other hand, you might think that antiquated devices like applying for the Chiltern Hundreds have long had their day and should be replaced by a modern arrangement.

The Chiltern Hundreds viewed from Taplow Station.

As the train moves along you might think about a particular MP who you believe should do the decent thing and use the device and leave the House of Commons. If you are in an especially bad mood, you might even want all 650 of them to do it. The Chiltern Hundreds can deal with a number of applicants in a short period of time. In 1985 seventeen Ulster Unionist MPs left the House of Commons in protest at the Anglo-Irish Agreement. Northstead and the Chiltern Hundreds coped with all of them on the same day. Your political views are a matter for you, but whatever they are enjoy the journey.

God's Wonderful Bridge

The Great Western Railway became known as the GWR, and as well as identifying the railway company the letters came to have two further meanings. One was 'Great Way Round' and this was because some of its lines did not take the obvious course of following the shortest route. The other, which was much more common and popular, was 'God's Wonderful Railway'. This reflected the widespread admiration for the company, its routes, its trains and its engineering accomplishments. One of these was the remarkable bridge over the River Thames between Taplow and Maidenhead. God's Wonderful Railway inspires the heading of this chapter.

As previously told the line westwards from London got as far as Taplow in 1838, but it could not extend further to Maidenhead until the River Thames had been crossed. This was a considerable challenge and the bridge was opened a year later. Trains then reached Maidenhead and onward towards Bristol.

It was, of course, Isambard Kingdom Brunel who designed the bridge and was responsible for its construction. It was one of his many great achievements on the line and elsewhere. Another of his railway masterpieces was the later Royal Albert Bridge over the River Tamar at Saltash. This linked Devon and Cornwall.

On the line between London and Bristol he designed and built the Box Tunnel between Bath and Chippenham. This goes through Box Hill. It is 1.83 miles long and the nature of the soil and rock made it particularly difficult to build. Sadly, around a hundred navvies died doing so, and their labour was illuminated only by candles. Construction commenced from both ends and when the two workings met the alignment was less than 2 inches out. The rising sun shines directly through the tunnel on just one day of the year, and after adjusting for leap years it is 9 April. This was Brunel's birthday, which he insisted was a coincidence. Many people thought that it was not.

As can be seen from the photograph Brunel's Maidenhead bridge has two arches and the central pier is built on a small island in the middle of the river. When it was built the bridge had the flattest yet widest arch is in the world. It is built entirely of brick and the rise is 24 feet. The width of each arch is 128 feet. A reduction in the forces acting through the brickwork was obtained by the use of internal longitude walls and voids. The bridge is approached on each side by a number of arches. The Thames towpath passes under the right-hand arch (facing upstream), and it is sometimes known as the 'Sounding Arch'. This is because it acts as an echo chamber. If you are ever there you could try it out by saying something like 'Manchester United are rubbish' then hearing your voice shortly afterwards.

The width and flatness of the arches was a matter of concern in some quarters, and the worriers included the directors of the Great Western Railway. They feared that the bridge

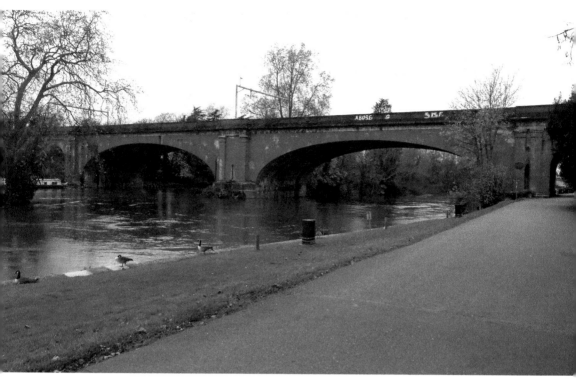

Brunel's bridge across the River Thames.

would not hold up, which would be an expensive shame at best and a fatal disaster at worst. Accordingly they instructed Brunel that the wooden framework used to support the arches during construction should be left in place. It seems unlikely that this would have had the desired effect and Brunel thought that it was unnecessary nonsense. He left the framework in place, but with the load supporting part very slightly lowered so that it had no effect. Some years later the framework was washed away and not replaced. The directors realised that their concerns had been unfounded.

The bridge was built to accommodate two broad gauge tracks. In 1861 dual gauge track was installed to allow both broad gauge and standard gauge trains to use it. During the late 1890s the bridge was widened to allow four standard gauge tracks. Happily the work was very sensitively done in order to preserve the original design and appearance.

It is perhaps not too fanciful to suppose that the great painter J. M. W. Turner shared my feelings about the bridge. His famous 1844 painting titled *Rain, Steam and Speed* shows a broad gauge engine and train crossing it in a rainstorm. It is a great and famous work that is now in the possession of the National Gallery.

For obvious reasons you will not be able to see the bridge when travelling over it. This could only be done if you are doing something illegal, dangerous or very probably both. So you will have to be satisfied by the photograph in this chapter. If you are ever in the area it is worth making the effort to have a look from the land. As a consolation for not seeing the railway bridge you might enjoy a beautiful view of the River Thames, which can be done from either side of the train. You might also like to look at the bridge that carries the A4 road over the river. This is Grade I listed and was built in 1777. It replaced

a series of structures dating back to the thirteenth century. It can be seen from the right side of the train.

It is remarkable to think that the railway bridge constructed more than 180 years ago is still in daily use. Furthermore, as well as slow trains and goods trains every few minutes, trains travelling at speeds of in excess of 100 mph thunder over it. Well done Isambard. You did a good job.

Maidenhead

Maidenhead Station is reached shortly after Taplow and even more shortly after crossing God's Wonderful Bridge. On reflection perhaps we should not take the name of the Almighty and instead call it Brunel's Wonderful Bridge. The photograph is of the Jubilee Clock Tower and it can be seen from the station on the right side of the train. It was taken from the station's platform just before the station buildings. The platform crosses a road bridge and the tower is located about 80 yards away on a small island in the middle of the road.

The Jubilee Clock Tower was erected to celebrate the Diamond Jubilee of Queen Victoria. It went up in 1899, but the sixtieth anniversary was actually on 20 June 1897. I thought that the good people of Maidenhead were rather tardy, but then I had better and more charitable thoughts. It would have been an awful embarrassment if Her Majesty had died after the erection but before the actual date. So perhaps they were wise to build it afterwards. The plaque on the tower reads:

ERECTED TO COMMEMORATE THE
DIAMOND JUBILEE OF HER MOST
GRACIOUS MAJESTY QUEEN VICTORIA
WHO ON 20TH JUNE 1897 COMPLETED
THE SIXTIETH YEAR OF A REIGN
UNPARALLELED FOR PROGRESS IN
ALL THAT MAKES FOR HAPPINESS
OF THE HUMAN RACE

GOD SAVE THE QUEEN

It is 46 feet tall and a visually pleasing structure. There are four clock faces and at the time of my visit they all recorded exactly the right time. You can see neo-Gothic and baroque flourishes, and also ornamental merlons and turrets with tracery. The clock faces have a diamond pattern that was inspired by the jubilee.

At the time Victoria was the only monarch whose reign had reached the sixty-year milestone, and she went on for another three and a half years. The closest was George III, who died five months short of his sixtieth anniversary. Victoria's record has since been exceeded by a large margin. Elizabeth II came to the throne on 6 February 1952.

The town of Maidenhead has a population of around 70,000. Like many towns and villages its origins can be traced back to Saxon times or earlier, and it appeared in the Domesday Book as the settlement of Ellington in the hundred of Beynhurst. In about the year 1280 a wooden bridge was erected over the river in order to replace the ferry, and this

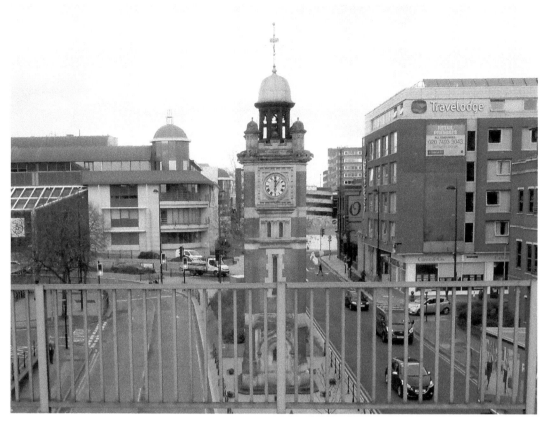

The Jubilee Clock Tower.

was subsequently succeeded by a number of other ones. The present bridge is Grade I listed and was opened in 1777.

The *c.* 1280 wooden bridge led to the growth of the settlement as a river port and market town. It became a coaching town and in the mid-seventeenth century ninety coaches a day were passing through. Not surprisingly it became noted for its coaching inns. Again not surprisingly the coming of the railway led to the town's further development.

In recent years the town centre has been extensively redeveloped, which unfortunately has caused the demolition of many old buildings of character. The town is now part of the so-called silicon corridor and has many modern offices. It is also a commuter town to London, but also to Slough and Reading. Property prices are high and especially so in the very attractive parts.

It would be remiss not to mention Maidenhead United Football Club. At the time of writing they play in the National League, which is the fifth tier of English football. One of their claims to fame is that they have played at their York Road ground since 1871. This makes it the oldest football ground in the world used continuously by the same senior club.

The river at Maidenhead is widely used for pleasure purposes. People love sailing, canoeing, walking along the towpath and generally having a good time. Boulters Lock is very well known and attracts visitors. It has been a site for pageants, carnivals and regattas, especially in Ascot week.

Unfortunately you will not see the Skindles Hotel because it was demolished in 2015. In late Victorian and particularly Edwardian times it had a reputation for racy, extra-marital assignations. More recently hotel guests included Princess Margaret, John Lennon and the former American president Richard Nixon. He was the man who famously said 'There will be no whitewash in the White House'.

The village of Bray is virtually a suburb of Maidenhead and the name immediately summons thoughts of fine dining. Two of the United Kingdom's five three-Michelin-starred restaurants are located there. One is the Waterside Inn, which was founded in 1972 by the brothers Michael and Albert Roux. In 2010 it became the first restaurant outside France to retain all three of its stars for twenty-five years.

The other restaurant is the Fat Duck, founded and run by the celebrity chef Heston Blumenthal. He is famous for his scientific approach to cuisine, and what he terms multi-sensory cooking. It results in very unusual dishes. The restaurant is noted for such delights as bacon and egg ice cream and snail porridge. I have never had the pleasure of visiting the Waterside Inn, but my wife and I have been treated by my stepdaughter and her husband to lunch at the Fat Duck. It was indeed a memorable and enjoyable experience, and we did partake in some fascinating or some might say bizarre culinary combinations.

Bray is not only famous for its restaurants. Other things include the satirical song 'The Vicar of Bray'. It tells the story of the vicar of the parish who was willing to modify his principles in order to retain his position. The monarch was head of the church and the vicar served during the reigns of Charles II, James II, William III, Anne and George I, and during the terms of both Tory and Whig governments. The vicar was subjected to different views on such matters as the divine right of kings and he bent with the wind as required. The chorus sung at the end of each verse is:

And this be the law, that I'll maintain
until my dying day, sir.
That whatsoever king may reign,
still I'll be the Vicar of Bray, sir.

At first sight the vicar in question appears to be Francis Carswell, who held the position from 1665 to 1709, but in fact the song is probably wholly fictitious. It is a good story though.

While researching this chapter I spent a pleasant hour or so in Grenfell Park, which is close to the station, and I decided to find out something about the man after whom it is named. This is William Henry Grenfell, Baron Desborough, KG, GCVO, DL. To mark Queen Victoria's Diamond Jubilee in 1897 he gave the land to the town. He had 10,000 acres so there was a lot left. The park contains a number of unusual trees, the seeds of which were provided by Grenfell following his extensive world travels.

To put it mildly Grenfell was an extraordinarily active man. As well as what follows, which is not a full list, he was a successful businessman too.

Let us start with his sporting prowess and interests. He rowed for Oxford in both the 1877 and 1878 boat races against Cambridge and he was President of the Oxford University Boat Club in 1879. At the age of fifty-one he won a silver medal for fencing at the 1906 Intercalated Games. These were at the time considered to be almost on a par with the Olympics. He was President of the Olympic Games held in London in 1908 and played a significant role in arranging them. He was President of the Marylebone Cricket

Club, President of the Lawn Tennis Association and President of the Amateur Athletics Association. He was also a Steward of Henley Royal Regatta.

Between 1880 and 1905 when he was raised to peerage he was three times a Member of Parliament, and he was Mayor of Maidenhead in 1895 and 1896. He was made High Sheriff of Buckinghamshire in 1889 and Deputy Lieutenant of the county in 1915. He was a Justice of the Peace and for five years Captain of the Yeoman of the Guard. We must not overlook that he was President of the London Chamber of Commerce, President of the Royal Agricultural Society and for thirty-two years he was Chairman of the Thames Conservancy Board.

In his spare time he enjoyed, cricket, golf, rowing, swimming and mountaineering. He swam the Niagara Rapids twice, climbed the Matterhorn three times and rowed across the English Channel. How on earth did he find the time to do it all? Just thinking about it makes me tired.

Twyford

Twyford is around 6 miles beyond Maidenhead. The first station opened in 1839 and for a short time this was the terminus for trains from London. Then a year later Sonning Cutting was ready and trains ran through it to Reading. The present station is the starting point of the Henley branch line, which was opened in 1859. St Mary's Church is about 300 yards from the station and can be seen from the right side of the train. The church and the adjacent war memorial feature later in this chapter.

Twyford is expanding but it is still a village. The 2011 census put the number of residents at 5,791, though it is rather more now. It has an aura of being a pleasant place to live and a pleasant place to visit. That must be a subjective judgement but it was certainly the effect that it had on me.

A particularly attractive feature of the village is the Loddon Nature Reserve, which is run by Berks, Bucks and Oxon Wildlife Trust. This is situated at the edge of the village. It features a large, flooded gravel pit that has several islands and a ragged, scrubby fringe that skirts around the shallows. The reserve provides ideal conditions for wintering birds and many other birds as well. Furthermore, the plant life attracts a range of butterflies, dragonflies and other aquatic insects. Bats may well be seen on summer evenings. Everything is interesting, valuable and beautiful as well.

Twyford's most famous resident was William Penn – at least he was if the tiny village of Ruscombe, which is just outside Twyford, is counted. He was the Quaker after whom the American state of Pennsylvania was named. He was born in 1644 and while still in his thirties Charles II settled an extremely large area of American land on him. This was in payment of a debt the King owed to Penn's late father and which he did not have the money to repay.

Penn spent very little time in America, but he implemented a democratic system featuring freedom of religion, fair trials and elective representatives. He treated native Americans very fairly, but according to the American Independence Hall Association there have been claims that he owned and even traded slaves. It is the case though that he did promote the good treatment of slaves. Whatever the truth we should perhaps be charitable and judge him by the standards of the seventeenth century rather than the standards of our own.

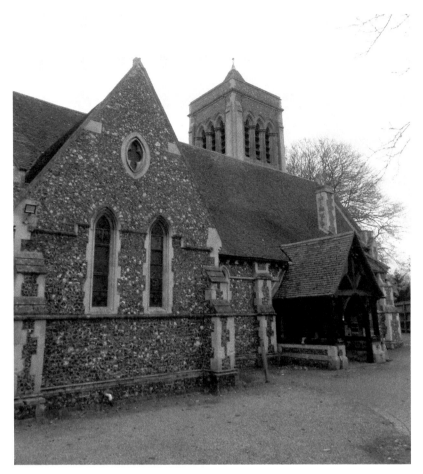

St Mary's Church.

Penn was by all accounts an admirable man, but a bad businessman and sometimes a bad judge of character. This led to him being the victim of a major swindle. As a result at the age of sixty-two he spent time in a debtors' prison. The last eight years of his life were at his home in Ruscombe and he died there in 1718. He was penniless at the time.

The name Twyford is derived from the Anglo-Saxon words for double ford. The River Loddon which is a tributary of the Thames splits into two near the village and after a while joins up. There were fords over each of the two channels and according to the chronicler Geoffrey Gaimer this had historical significance.

Gaimer states that in the year 871 the King of Wessex, Aethelrid, and his brother Arthur were defeated by the Vikings at the Battle of Reading. Chased by the victors, they escaped over one of the fords that their pursuers did not know existed. Had they not done so the country's story might have taken a different course. Alfred is known to history as the future King Alfred the Great. It is only a legend but he is the man who supposedly burnt the cakes when being sheltered by a peasant woman. He was a great man and a successful King. Britain would have been rather different if he had been captured and killed.

St Mary's is a large Church of England place of worship in Station Road, Twyford. It was built in 1847, then extended in the 1880s. The tower was built in 1910 and the peal of bells was hung in 1913. The tenor bell was named 'George' to mark the coronation of

George V. A pleasing feature within the burial ground is the well-kept Millennium Garden Centre Piece. My visit was during the Covid-19 restrictions, but I was told that despite this, attendance for the Sunday morning services were up to the impressive figure of seventy. The limited number was necessary because of social distancing requirements.

In the church I immediately noticed around fifty kneelers, which are for the worshippers to kneel on during prayers, and were all made by people associated with the church. They were individually made to various eye-catching designs and colours and they were all of a very high standard.

The next thing that caught my eye was an exquisite lace design in the form of a church window – a small window obviously. It contained six different types of bobbin lace and underneath were the signatures of the twelve local lacemakers who made it. They presented it to the church in 1997 to mark its 150th anniversary.

Plaques on the church wall commemorate the lives of Sir Henry William Verey (1836–1920), his wife Henrietta Verey (1838–1933) and their son Henry Edward Verey DSO (1877–1968). It was a long-lived family. Sir Henry was a barrister and held the office of Official Referee of the Supreme Court for the extraordinarily long period of forty-four years. His other claim to fame is that he was the grandfather of the actor Dennis Price, who was born in Twyford in 1915.

War memorials sometimes make me feel emotional. I think of wives and mothers watching the telegraph boy coming down the street and praying that he will pass by, and the Twyford one had this effect. It is situated at the edge of St Mary's churchyard and it was dedicated on 14 November 1920. During the service the church was full and around 500 people were gathered outside. The memorial lists twenty-eight names from the First World War and a further ten from the Second World War. Unusually the First World War names are grouped by the years of their deaths.

It seems right to conclude with the story of one of the fallen and the following is based on research carried out by the amateur historian Paul Aplin. With much else beside it is available online and my thanks are due to him. I have selected Albert Edward Hunt, though it could have been many others. He was born in Twyford in 1888 and was one of thirteen children. Four of his brothers also served and happily they all survived. Albert died on 18 October 1914 when his submarine was torpedoed by a German submarine. It was the first time that a submarine had been torpedoed by another one. Please think of him and the thirty-seven others when you read this chapter.

Sonning Cutting and the 1841 Christmas Disaster

It is only a short distance from Twyford to Reading, and Sonning Cutting is just before Woodley on the outskirts of this town, which is the subject of the next chapter.

The village of Sonning is on the right side half a mile from the line, and it is situated on the River Thames. It is beautiful, historic and very decidedly upmarket. Famous residents include George and Amal Clooney and the former prime minister Theresa May. From many years personal experience my wife and I can strongly recommend the Mill at Sonning Theatre. In his book *Three Men in a Boat*, published in 1889, Jerome K. Jerome described

Sonning as 'the most fairy-like little nook on the whole river'. He would probably feel much the same now, but it is safe to assume that he would be shocked by the property prices.

Powerful local interests stopped the line being routed through the village or very close to it, so Brunel was obliged to build a tunnel or a cutting through Sonning Hill. He elected to have a cutting, which was a massive and expensive enterprise. The cutting's depth can be gauged by the photograph in this chapter. It is 60 feet deep at the deepest point, and it is more than a mile long. There were a number of springs, and the soil to be shifted was sand and clay. At the deepest part it was necessary to remove 7,800 cubic yards of spoil to secure progress of one foot. The work was done by navvies and the spoil was removed in wheelbarrows and horse-drawn carts.

Progress with the excavation was initially good, but in March 1837 the contractor upset his labourers by imposing lower wages. It is believed that he was experiencing financial difficulties at the time. From then on the forward movement became increasingly disappointing, and in August 1838 the railway company finally lost patience and dismissed the contractor. Navvies were in many ways splendid people, but for a while local communities were wary and unhappy as a large number of them loitered with no work and not much money. A couple of months later the replacement contractor was also sacked and the work continued under the direction of GWR's engineers. To use a modern term it was brought in house.

This was more successful and in February 1839 1,220 men, 196 horses and two locomotives were busily engaged in the work. There were reports that the intense seven days a week working upset local church interests who thought that Sunday should be a day of rest. However, the work continued as before and the tracks were laid in early 1840.

Following some successful trial runs everything was ready for an inspection by the directors on 17 March. A special train carrying some of them and other notable people as well went down to Sonning from London. It was personally driven by Daniel Gooch, the first Superintendent of Locomotive Engines for the Great Western Railway. Still aged only twenty-three, Gooch was a remarkable man. In his future career he was instrumental in laying the first transatlantic telegraph cable, for which he was created a baronet. He was Chairman of the Great Western Railway for twenty-four years and a Conservative Member of Parliament for twenty years.

The first scheduled train to pass through the cutting left Reading for London on 30 March 1840. The cutting that may be seen today is not as steep as it was in 1840. In 1892 broad gauge running was replaced by standard gauge and four standard gauge lines replaced two broad gauge ones. To accommodate this there was a major rebuilding of the cutting. It was widened at the base and the sides were made less steep. Also, sturdy retaining walls were inserted.

Following the 1840 opening frequent inspections were necessary. This was because of a number of small slips from the side caused by water building up below the surface. It was then necessary to remove the spoil, drain the water, then remake the contour. Such a slippage was the cause of a dreadful accident in the early morning of Christmas Eve 1841.

The unfortunate train left London at 4.30 a.m. It consisted, in the following order, of an engine, a tender, three third-class passenger carriages and a number of heavy trucks. The carriages were open topped and carried about thirty-eight passengers. Many of them were stonemasons returning home for Christmas after working on the new Parliament buildings.

The engine hit some spoil that had come down from the side of the cutting. The three carriages and especially the front one were compressed into the tender and very extensively damaged by the weight and motion of the heavy goods trucks behind. Eight people died at

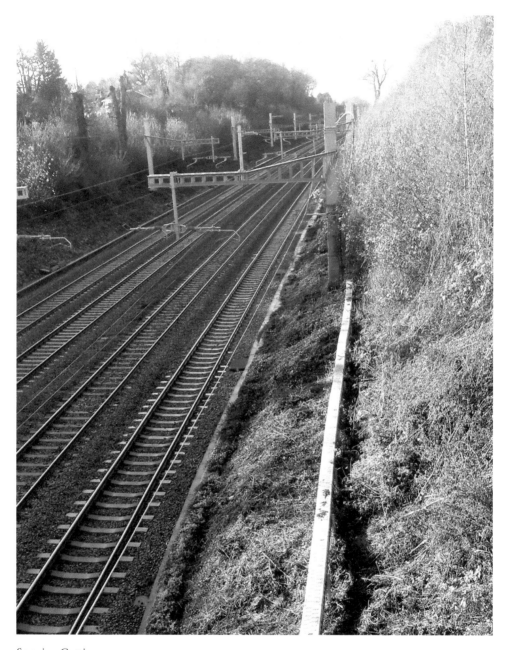

Sonning Cutting.

the scene of the crash and seventeen were taken to the Royal Berkshire Hospital in Reading. One of them died six days later, making nine deaths in all. On hearing of the crash Brunel took a special train with about a hundred men to the site in order to clear the line so that services could be resumed.

It is now normal for inquests to be held some time after the relevant deaths, but they did things differently then. The inquest on the eight people who had died at the scene of

the crash was held in a local inn and it opened formally during the afternoon of Christmas Eve. At 9.00 a.m. on 28 December the twelve jurors were sworn in by the coroner and they started hearing evidence. A witness said that a few days before the accident he had seen two workmen shovelling a small amount of spoil away from the side of the track and that the slip had not been made good. Brunel asked him if he knew that drains were normally left open to drain them. He replied that he did not know this. Other witnesses gave evidence that they had noticed slips in the previous weeks, and one said that one of the slips was close to the point of the crash.

Brunel in his evidence said that his investigations had shown that the slippage that had caused the fatal crash was a new one. It was close to a previous slippage but there was no connection. The positioning of the three passenger carriages at the front of the train was a contentious issue because had they been at the back the passengers may have been unhurt. The injuries would almost certainly have been less severe. Brunel said that the front would normally be the safest place for them. He added 'many accidents might arise to passengers if placed in the rear of the luggage trains'. This was because in the early days of railways signalling was primitive and there had been instances of trains running into the rear of ones in front. For what it is worth, not much you might think, I believe that Brunel was right in the circumstances of the time. It was, though, dreadfully unfortunate for the passengers on this particular train.

The coroner's jury returned a verdict of accidental death in all eight cases and awarded a deodand of £1,000 on the engine, tender and carriages. It was later revealed that the jury felt that great blame attached to the company in placing the passenger trucks so near the engine and that great neglect had occurred in not employing a sufficient watch on the cutting when it was most necessarily required. There was later a further inquest on the passenger who had died in hospital. The jury heard similar evidence and returned the same verdict. They awarded a deodand of £100 and recommended that in future passenger trucks be placed further from the engine.

You may, like me, need to ascertain the meaning of the word 'deodand'. They had been in existence for many centuries and their use had evolved over time. In 1841 a coroner's jury could impose it on the owner of an animal or piece of machinery that caused the death of a human being. The money was to go to a worthy religious or charitable cause. Deodands were abolished by Parliament in 1846.

The Sonning Cutting crash was one of the issues on the mind of the President of the Board of Trade, William Gladstone, when he presented the Railway Regulations Bill to Parliament. Among other measures it provided that all passenger accommodation must be provided with seats and roofs. This might have reduced the carnage at Sonning, but was in any case a civilised measure. Third-class travellers were frequently travelling in open trucks with no seats, to say nothing of no toilets. This last sanitary and comfort issue was not addressed by the Bill.

Another measure was the requirement that all stations must have at least one train a day travelling in each direction, and that at least one train per day must not charge more than one penny per mile. The companies complied with the letter of the law but not always with the spirit of it. Most of them withdrew the option of second-class travel, leaving just first class and third class. This was in the hope of preserving revenue by incentivising second-class travellers to move to first class rather than travelling with the hoi polloi in third. This apparent anomaly lasted until 1956 when third class was rebranded as standard class. Mr Gladstone's Bill became the Railway Regulations Act 1844.

Reading

It is only a short distance from Twyford Station to Reading Station, and Sonning Cutting lies between the two, so Reading is reached shortly after leaving the cutting. The original Reading Station was opened on 30 March 1840 and the quickest train to London was scheduled to take sixty-five minutes. This was at an impressive at the time average speed of 39 mph. The line from Reading to Bristol was completed in 1841.

The original station has been replaced and then redeveloped a number of times. The most recent redevelopment was opened by the Queen in 2014. It is now, to me at least, a very impressive, modern structure including escalators, lifts, shops and other features. The station is both large and busy. In fact it is behind Birmingham New Street as the second busiest interchange station outside London.

The photograph is the statue of Edward VII and it was erected to commemorate his coronation on 9 August 1902. It is a notable landmark and it is located on a small island immediately outside the main station entrance on the right side of the train. It is bronze and it stands on a polished granite plinth. The sculptor was George Edward Wade. The notable Reading landmark was financed by a private citizen in honour of his late father who had lived all of his eighty-six years in the town.

It is certainly impressive and the many words on the plinth commence with 'His Majesty Edward VII, King of Great Britain and Ireland and the British Dominions Beyond the Seas, Emperor of India'. It reflects national pride in the new Edwardian era in what was still the age of empire. The reference to Ireland reflects the fact that all of Ireland was still part of the United Kingdom, as it had been since 1 January 1801. The inscription continues 'Coronation of His Majesty King Edward VII 1902. Record of the Commemorative Celebrations and Public Rejoicings in the County Borough of Reading.'

The very long list that follows indicates that the people of Reading really did have rather a good time. It includes, but is not limited to, dinner for 2,000 aged persons, tea for 14,500 school children, aquatic sports, a water carnival with procession of illuminated and decorated boats and steam launches, and decorated carriages including automobiles and cycles.

The statue is a good likeness but kind to its subject. It shows him as a rather slim and athletic-looking man, which was far from the truth. The new king, sixty-one at the time of his coronation, was a glutton who was seriously overweight. As well as this he smoked heavily and taken together these things probably contributed to his death just eight years later. A glance at contemporary photographs indicate his size. No one dared say it to his face but one of his nicknames was 'tum tum'.

Edward had not enjoyed a good relationship with his mother, Queen Victoria, and he had not been well prepared for his role as monarch. He had been a playboy Prince of Wales, enjoyed the company of many mistresses and was involved in quite a few scandals. Despite all this and to the surprise of many he is generally regarded as having been a good king. The people of Reading would have enjoyed the celebrations and not been disappointed afterwards.

I came to Reading with fond memories and high expectations. This was because at an early part of my career I spent a happy year working for the Midland Bank in the centre of the town. While doing this I sometimes ran the bank's sub-branch in Sonning. This is the very prosperous and picturesque village mentioned in the last chapter. It was open twice a week for just a few hours and usually there were only a handful of customers. It was good

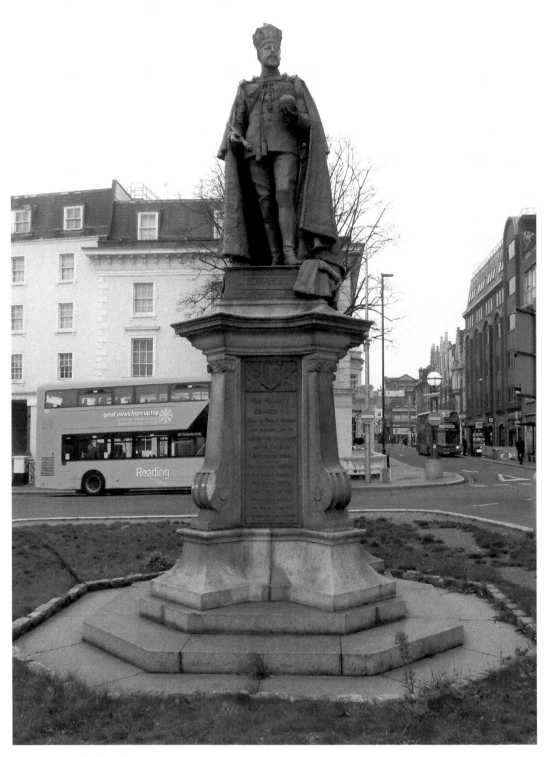

Statue of Edward VII.

training because I was the only one there and I had to deal with whatever questions they asked. My friends and colleagues referred to it as the sodding sub-branch.

While preparing this chapter I drove to Reading and on arrival I encountered problems. Whatever I did I got locked into one-way systems and had to drive a long way to somewhere that I did not want to go. This happened three times but I did finally find the station. After a restorative cup of Caffè Nero's finest coffee with a suitable cake the day got better and my feelings of affection towards the town returned.

There was, though, an unpleasant surprise to come. A few days afterwards two identical envelopes with Reading postmarks arrived in the same delivery. Each contained a penalty notice for driving in a bus lane. They were both supported by timed photographs and I was clearly at fault. That two transgressions were just nine minutes apart. Starting at the age of seventeen I have driven something like 750,000 miles and they were the first penalties of this kind. For all of ten seconds I hated Reading, but the feeling soon passed. I enjoyed the visit and the happy memories outnumbered the other ones.

It is safe to surmise that three famous writers had negative feelings about the town. In ascending order of both their fame and justification for their dislike they are Jerome K. Jerome, T. E. Lawrence and Oscar Wilde.

Jerome was the author of *Three Men in a Boat* and his favourable view of Sonning is mentioned in the previous chapter of this book. Jerome starts chapter sixteen of his book with 'We came in sight of Reading about eleven. The river is dirty and dismal here. One does not linger in the neighbourhood of Reading.'

Colonel Thomas Edward Lawrence is perhaps better known under the sobriquet of Lawrence of Arabia. He was an archaeologist, diplomat and writer, but is best known for his exploits fighting the Ottoman Empire during the First World War. After the war he wrote the book *Seven Pillars of Wisdom*. The title was inspired by a biblical reference. Proverbs Chapter 9 Verse 1 reads *Wisdom hath builded her house, she hath hewn out of her seven pillars*.

In late 1919 Laurence changed trains at Reading when taking a draft of the book to his publisher. He was travelling on the second train when he realised that he had left the package in the station buffet. He returned as quickly as possible but his work was irretrievably lost. The missing draft was 250,000 words long. He had not kept a copy and he had not kept any notes, so he had to rewrite it from scratch.

When eventually published the book was a great success and regarded as a masterpiece. Sir Winston Churchill subsequently wrote 'it is unsurpassed. It ranks with the greatest books ever written in the English language'. The 1962 film *Lawrence of Arabia* starring Peter O'Toole is based on the book, though in many ways it departs from the true story.

Oscar Wilde was a famous playwright, novelist and wit, and he was well known for other things too. His plays included *The Importance of Being Earnest* and he wrote the novel *The Picture of Dorian Grey*. On 23 November 1895 he was in handcuffs as prison officers escorted him through Reading Station to serve the final part of his prison sentence in Reading Gaol. On the station platform a crowd of people jeered and spat at him.

Wilde was married with two children, but for some time he had engaged in illegal homosexual practices with a number of men. Some were affairs of the heart and some were with male prostitutes. His downfall was an affair with the youthful Lord Alfred Douglas, who was the son of the Marquess of Queensberry. On 18 February 1895 Queensbury left his calling card at Wilde's club. It was marked 'For Oscar Wilde, posing somdomite (sic)'.

Against the advice of many friends Wilde sued him for criminal libel. The Marquess successfully defended the case on the grounds that the words were true and made in the

public interest. The costs awarded against Wilde bankrupted him and he was subsequently charged with and convicted of various acts of gross indecency. His sentence was the maximum permitted, namely two years' imprisonment with hard labour.

After his release Wilde went to France and died there three years later. During this time he wrote his last poem 'The Ballad of Reading Gaol'. It was long (654 lines) and successful. For the first two years of publication Wilde was not acknowledged as the author, though many people guessed. The poem was inspired by the hanging of a murderer at Reading Gaol at the time that they were both incarcerated there.

In 1995 Wilde was honoured with a stained-glass window at Poet's Corner in Westminster Abbey. In 2017 he was among the men posthumously pardoned because what he had done was no longer against the law. The Second World War codebreaker Alan Turning was pardoned at the same time for the same reason.

Two Charming Riverside Villages

Pangbourne is 5 miles beyond Reading and after a further 3 miles Goring-on-Thames is reached. These are the two charming riverside villages and the ones with stations through which the line passes. This chapter could, though, have been titled Four Charming Riverside

Premises of H. R. Owen Motor Group.

Villages. Pangbourne, on the south side of the Thames, is linked by a toll bridge to the smaller village of Whitchurch. The cost for my car was a not unreasonable 60p. Goring-on Thames on the north bank is linked by a bridge to the village of Streatley. The river is close to the right side of the line from Reading, then crosses it shortly before Goring-on-Thames.

Pangbourne is a large village with distinctive shops, which I found very attractive. In fact I found it charming, hence the title of this chapter. I particularly liked the look of the Pangbourne Cheese Shop, which has won the Cheesemonger of the Year and other awards. Unfortunately it was closed at the time of my visit so my pleasure was only visual.

The River Pang joins the Thames at Pangbourne so it is easy to see how the village got its name. Writing in 1919, D. H. Lawrence, most famous for his book *Lady Chatterley's Lover*, referred to the place as Pongbourne and said that the women smelt and were repulsive. I suspect that this was not true then and it is certainly not true now. The village is positively fragrant. Kenneth Graham, who wrote *Wind in the Willows*, held much more favourable views. He spent his retirement in the village and it is believed that the character of Ratty in this his most famous book was inspired by the water voles in the River Pang.

The photograph shows the premises of the H. R. Owen Motor Group. This can be seen on the left side of the train from the bridge just before Pangbourne Station. If you want very luxurious, very prestigious, very fast and very expensive cars, this is the place to come. I do, but they are out of my price range. Nevertheless, I enjoyed the window shopping. The premises is for the sale and servicing of new and second-hand Bentleys, Aston Martins and Lamborghinis. A large number of them were on display.

Bridge linking Goring with Streatley.

The station after Pangbourne is Goring but it is named Goring and Streatley. The photograph, which was taken on a foggy December day, is of the rather attractive bridge linking the two communities. You will almost certainly be safe but the two villages were once on opposite sides during a war. It happened in the year 795 when Goring was in Mercia under King Offa and Streatley was in Wessex under King Ine.

Goring, which is mentioned in the Domesday Book, is located in the Goring Gap, which separates the Berkshire Downs and an outcrop of the Chiltern Hills. Both Goring, which is in Oxfordshire, and Streatley, which is in Berkshire, are attractive villages that are smaller than Pangbourne. It is worth noting that most of the shops are in Goring.

The parish church has a very long history and is worth a visit. It was built early in the twelfth century and the bell tower was added in the fifteenth century. It has a ring of eight bells, one of which dates back to 1290. The rood screen is carved from wood taken from HMS *Thunderer*, which fought at the Battle of Trafalgar.

Cholsey and the Mysterious Earthworks

Cholsey Station is 48 miles from Paddington and halfway between Goring and Didcot. The original station, opened in 1840, was known as Wallingford Road and it was located several hundred yards closer to Goring. This was replaced by the present station in 1892 when the line was quadrupled.

A branch line from Cholsey Station to Wallingford was opened in 1866. This closed for passenger trains in 1959 and for freight in 1981. The line became popularly known as 'The Bunk'. It seems that on one occasion an engine set off without the carriages, which had not been attached. In fact it had done a bunk. The Cholsey and Wallingford Railway Preservation Society reopened the line in 1985. It runs trains 2.5 miles from Cholsey Station to the edge of Wallingford, but only on special days. Most trains are pulled by diesel engines but sometimes it is steam.

Cholsey is a small village with a very long and interesting history. There is a large Bronze Age site within the parish and strong evidence of Roman occupation has been noted. It was founded on Ceol's Eye (or Ceol's Isle), which was on marshy ground close to the River Thames. It is not hard to discern the derivation of the name Cholsey. Ceol was King of Wessex from 591 to 597 and the Wessex royal family owned land in the area.

In 978 Queen Ælfthryth was involved in the murder of her stepson so that her own son could be king. The boy beneficiary was only twelve at the time and was not involved in the plot. He is known to history as Ethelred the Unready, but this is not fair. He was a good king and a better translation is Etherlred the Poorly Advised.

As an act of repentance Ælfthryth founded a nunnery in Cholsey. It was later destroyed by the Danes and later still its lands passed to the monks of Reading Abbey. In the thirteenth century the monks built an extraordinarily large tythe barn in the village in order to store the tythes given to them. It was 303 feet long, 54 feet wide and 51 feet high. It is said to have been the largest aisled building anywhere in the world at the time, though it is hard to see how anyone could possibly know. Very unfortunately the barn was destroyed in 1815.

The village green is known as 'The Forty', which is believed to mean 'island in the marshland'. It features a very large and splendid tree that different sources identify as either a horse chestnut or walnut tree. Having visited it I can confirm that it is a horse chestnut tree.

My Ordnance Survey map indicates that there are monastic earthworks in a field immediately adjacent to the station. I looked forward to seeing them, but during a fruitless half hour walking round a muddy field in fading light I failed to find them. I failed again in better conditions on a subsequent visit and decided that I must take advantage of local knowledge. So over a cup of coffee in a café by The Forty I asked some local residents. No one could help but then an elderly man who had spent his entire life in the village arrived and he was bound to know, or so I was told. In fact he did not know and be became alarmed because he thought that I was telling him that earth moving machinery had been put into the field.

It got worse. Mr Google was consulted and the monastic earthworks had a small mention and so did earthworks near St Mary's Church. These were said to be evidence of a Norman siege castle. With great anticipation I went to the church but I could not see these either. I spoke to a former church warden who was walking his dog, and he had no knowledge of them or of the ones said to be near the station.

Grave of Dame
Agatha Christie.

The St Mary's Church was founded by King Ethelred in 986. Much of the present building dates from the early twelfth century, though it contains some Saxon masonry. The sanctus bell was cast between 1290 and 1310.

The church's extensive burial ground includes the grave of Dame Agatha Christie, and it is her tombstone that is shown in the photograph. She lived in Cholsey with her second husband, the archaeologist Sir Max Mallowan, for forty-two years until her death in 1976 at the age of eighty-five. Her husband remarried but died just two years afterwards. He is buried with Dame Agatha in the grave shown on the photograph. Agatha Christie was a very popular writer and by some accounts was the bestselling fiction writer of all time. People still pay tribute to her by visiting the grave and leaving notes and flowers.

Didcot

Didcot Parkway Station is 5 miles beyond Cholsey and next to the very well-known Didcot Railway Centre. The centre deserves and gets a chapter all to itself.

The photograph is part of the Orchard Centre Development, which is at the end of Orchard Street. It can be seen from the left side of the train just before it reaches the station, and it is necessary to look over a car park. It is at the end of Orchard Street and I thought that it was rather attractive. You may see the M&S Food Hall, Sainsbury's, Next, which is prominent in the photograph, and other retail outlets. Costa, which I visited, is in the corner.

The reminiscence is inconsequential, but while in Costa I suffered (literally) a minor misfortune while saving myself 50p. The charming assistant tried hard to interest me in a superior blend of Columbian coffee that cost 50p more, but I resisted her blandishments and bought the cheaper option. Then before taking even a sip I spilt the whole contents of the very hot liquid all over my trousers. It was painful but not as expensive as it would otherwise have been. The replacement cup was delicious.

Didcot has a heritage of being a so-called railway town. Without the railway it is unlikely that it would have developed as it did. The Great Western Railway reached it in 1840 and in 1844 the line from Didcot to Oxford commenced operating. At the same time one of the many Brunel-designed stations was opened at the junction. It is at Didcot that the line to Oxford parts from the one to Bristol, the south-west and south Wales. Some years after 1844 the station burned down and was replaced.

It is instructive to reflect on just how fast for the time were the early Great Western trains. In December 1847 the scheduled time from London to Exeter, a distance of 194 miles, was four hours and twenty-five minutes. This included the non-stop run for the 53 miles from London to Didcot in fifty-five minutes at an average speed of 58 mph. It was claimed, probably correctly but without proof, that on 11 May 1848 the run from Paddington to Didcot was made in forty-seven and a half minutes. If this is true, the average speed was 67 mph.

The Didcot, Newbury & Southampton Railway opened in 1882. This linked the south coast with the Midlands and it was important in both of the world wars. This line was closed to passengers in 1962 and to freight in 1966. A new station building was opened in 1985 and at the same time the station was given its present name of Didcot Parkway.

Important as the railway development has been and small as the village was before it happened, very ancient history is worth a mention. It is believed that the area has been inhabited for 9,000 years or more. Some years ago, an archaeological dig found evidence from the Mesolithic, Neolithic, Iron and Bronze Ages.

The town was the birthplace of a man (or should I say boy) with a remarkable record. Ken Lester was Britain's youngest ever male Olympian. He was only thirteen when he competed as the cox in the coxed pairs at the 1960 Summer Olympic Games.

For nearly all of its existence Didcot was in the county of Berkshire, but in 1974 it was transferred to South Oxfordshire. It would have been controversial at the time and the cause of some discontent. Didcot is now in the parliamentary constituency of nearby Wantage. No doubt the local government officers of the town are models of propriety and treat youthful, female residents with the greatest respect, but just possibly this was not always the case. Limericks are sometimes inspired by real life events and people. Consider:

There was a young lady of Wantage;
Of whom the Town Clerk took advantage;
Said the Borough Surveyor;
You'll just have to pay her;
You've considerably altered her frontage.

The Orchard Centre Development.

It could be worse. There is no connection to Wantage or Didcot but consider the reputation of Sir Gerald du Maurier, a prominent actor who died in 1934.

> There was a young lady called Gloria;
> Who was had by Sir Gerald du Maurier;
> She was had by six men;
> By Sir Gerald again;
> And by the band at the Waldorf Astoria.

I do not know what Sir Gerald's feelings were, but I like to think that he would have been amused. It might have been good for his career.

Had you been making the journey some years ago you would have been struck by the bulk and dominance of Didcot A Power Station. This was coal and gas-fired and it started generating power in 1970. The main chimney was 660 feet tall and the six cooling towers, which were arranged in two groups of three, were each 374 feet tall. Coal and oil were supplied by a loop from the Great Western main line.

The building of the power station was controversial. In exceptional weather conditions it could be seen from 30 miles away and although it had admirers, and of course provided both jobs and power, many considered it to be a blot on the landscape or even a monstrous blot on the landscape. *Country Life* magazine once voted it the third worst eyesore in Britain.

Before moving on I must tell you that the last part of this chapter includes a tragedy. Didcot A stopped generating electricity in March 2013 and three of the cooling towers were demolished with controlled explosions in July 2014.

In February 2016 a large part of the boiler house collapsed while it was being prepared for demolition. One person was killed, five were injured and three were missing. In addition, fifty people were treated for the effects of dust inhalation. Due to the instability of the structure, it was not possible to try and recover the bodies of the three missing men, who must surely have died. In July the same year what remained of it was demolished in another controlled explosion. The remaining three cooling towers went the same way in August 2019. The 660-feet-tall chimney was brought down in 2020. The collapse must have been quite a sight.

The missing three bodies were ultimately recovered. At the time of writing the inquiry into the causes of the tragedy is continuing. Manslaughter and health and safety prosecutions remain a possibility.

Didcot Railway Centre

At Didcot Parkway Station the line to Oxford parts company from the line to Bristol and other points west. The Oxford line curves off to the right. Didcot Railway Centre is very close to Didcot Parkway Station and it is located between the two lines. The only access to it is from the station. It is necessary to go through a tunnel under the main line to the west. Staff at the barrier will let visitors through and they need to see Railway Centre tickets for the barrier to be opened when they come back.

The Railway Centre covers 21 acres and is centred on the steel and brick engine shed built in 1932. This replaced the old timber-framed building. The new facility included a

repair shop, a coaling stage, a sand furnace, a turntable and office quarters. In the 1960s steam was replaced by diesel and the shed was no longer needed.

The site was reopened in 1967 as a museum by the Great Western Society. This is Registered Charity No. 272616 and it has around 4,000 members. The great things that it does do not fund themselves so needless to say financial contributions are appreciated. The Railway Centre is largely run by volunteers and new ones are welcomed. There are around 50,000 visitors each year and there is much to do.

The tall and bulky building in the photograph is of what is described as the Coal Stage, and it was taken by the writer from one of the platforms at Didcot Parkway Station. As well as being a high and bulky building, it is situated next to a raised ramp, so this combination makes it dominate the view. It was and is used to coal and water the steam engines. The large tank at the top of the building supplies water through pipes to the water cranes, which can be seen in front of the engine shed. Coal is brought into the building by wagons, which are propelled up the long ramps. It is then unloaded into wheeled tubs. These are tipped into the tender or bunker of a locomotive.

The next most prominent building is the engine shed, which faces visitors on arrival. Engines that are not in use at the time or restored for static display can be seen in or around it. Some of them can be classed as great locomotives and all of them are of interest.

As might be expected broad gauge track and old facilities and equipment are available for viewing. Particularly interesting to me is *Fire Fly*, a replica of a broad gauge locomotive designed by Daniel Gooch in 1840. It was the first one designed by the great man, who was the first Superintendent of Locomotive Engines on the Great Western Railway. He was twenty when he was appointed to this position and twenty-three when he designed this engine.

It was a locomotive of this class that hauled Queen Victoria's first ever venture on to a railway. She was twenty-three at the time and she had been Queen for five years. It took her from Slough, which is near Windsor Castle, to Paddington. It was in 1842 and the journey

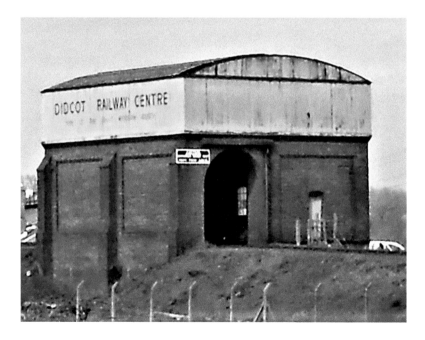

The Coal
Stage.

took twenty-five minutes. Brunel was on the footplate. The anxious Queen had made it clear that the train must not exceed the speed of 30 mph. She had only given a few days notice of her wish to make the journey by train and it was a rush for the railway company to prepare the sumptuous carriage. It had a padded silk ceiling, blue velvet sofas, matching silk curtains, fringed lampshades, fine mahogany wooden tables and thick carpets.

Interesting carriages and wagons can also be seen, including carriages dating from Victorian times. They include a travelling post office and a VIP saloon believed to have been used by General Eisenhower during the Second World War. It was definitely used on GWR's royal train. Other highlights include broad gauge track, mixed grade track, a broad gauge turntable and a more recent locomotive turntable. In addition there is a disc and crossbar signal and literally thousands of exhibits.

You would be disappointed if you could not have a ride, but be of good cheer. You can. The main demonstration line is half a mile long and there is also a branch line. Special events are periodically arranged. Finally, what about a gift shop and what about refreshments? No visit to a place such as this would be complete without them. Once again be of good cheer. You would not be disappointed.

Culham and the Science Vale

The so-called Science Vale is close to Didcot and it consists of three large and important science and technology centres. They are in the villages of Culham, Milton and Harwell. The line to Oxford runs through the area and through Culham, which is 3 miles from Didcot.

Culham Station is small and the original station building, which is Grade II listed, is no longer in use. Like so many GWR structures it was designed by Brunel. Culham Village is also small, one night almost say tiny, though the Science Centre is just outside it. The village would have been even smaller in 1844 when the station was built. It is perhaps surprising that the railway company thought that a station was justified in that place at that time.

Regardless, it earned its keep at the outbreak of the Second World War in 1939. In a short period 4,000 child evacuees from London passed through it. Well done the railway and well done the good citizens who met them and took them in. Well done the children too. Most of them thrived, though sadly not all of them. Many of course went back home during the phoney war of 1939/40 and some were caught in the bombing.

The village of Calham has more than twelve centuries of recorded history, which is quite a thought. Think of William the Conqueror, then go back a quarter of the preceding millennium.

Culham Manor is a historic manor house set in 11 acres. It was originally a medieval barn, built around 1420 and held by the abbots of Abingdon. The Dissolution of the Monasteries took place around 1538 and at this time it was seized by Henry VIII and then sold by him. It was restored around the time of the Second World War.

The manor's sundial and dovecot are particularly interesting. The sundial was put in place in the seventeenth century and it is on a stone column that is considerably older.

The dovecot was built in 1685 and it has the distinction of being the second largest one ever built in England. Dovecots were built for the breeding and keeping of doves or pigeons, partly as a source of food and partly to indicate high social status. The one at Culham Manor has no fewer than 4,000 interior nesting boxes. When it was in use there

must have been the most awful mess inside and around it. The possibilities are so awful that it brings to mind some relevant poetry:

> Little birdie flying high;
> Dropped a message from the sky;
> Said the farmer rubbing his eye;
> It's a jolly good job that cows can't fly.

The house, the dovecot and the sundial are all Grade II listed.

Culham Old Bridge crosses a backwater of the River Thames and it is scheduled as an Ancient Monument. The bridge was built in 1416 and in 1644 it was the site of a battle in the English Civil War. At the time it was held by the Parliamentarians and it was of strategic importance. A Royalist attempt to remove them failed and their leader, Sir Henry Gage, was killed in the endeavour.

I approached Culham Science Centre with some knowledge of the work that was done there, but it had not occurred to me that very evident security measures would be in place. The photograph accompanying this chapter shows very clearly that there was. I reported to the gatehouse and explained who I was, what I was doing and that I would like to take a photograph from outside. A charming lady said that she did not think that it would be a problem, but that she would refer the request to the appropriate manager. Permission was duly given but I was asked not to take the photograph from a certain position. She told me that heightened security had been in force for a considerable time.

The Culham Science Centre was built on the site of the old Royal Navy Air Station HMS Hornbill. Culham Laboratory was opened in 1965 taking some operations from nearby Harwell, and others from different UK locations. The Culham Centre for Fusion Energy (CCFE) is located inside it. The name was given following organisational changes at its parent body, the United Kingdom Atomic Energy Authority (UKAEE). It was later chosen as the site for Joint European Torus (JET) tokamak.

At this point I must declare a failure and a problem. I found it exceedingly difficult to understand what happens there and I cannot say that my endeavours to find out were successful. The veritable alphabet soup of acronyms did not help. Three of them are mentioned in the last paragraph. I am therefore reproducing some extracts from the Culham Centre for Fusion Energy's website. I hope that they help.

> The UK Atomic Energy Authority created Culham Laboratory as a purpose-built home for Britain's fusion research programme. The laboratory soon established a leading reputation for fusion science. By 1983, Culham had built over 30 different experiments - more than one per year – testing a variety of machine concepts.
>
> …an ambitious project to design a large multinational tokamak. Their aim was an experiment that would get close to reactor conditions and show that fusion could produce significant quantities of power. The machine came to be known as JET – Joint European Torus. Culham was chosen to host JET in 1977 and the 'first plasma' was produced on 25 June 1983.
>
> From the 1990s onwards, Culham has led the development of the 'spherical tokamak'. This is a more compact tokamak design with excellent potential for smaller, cheaper fusion devices. Culham built the first large spherical tokamak – START – in 1991. This was followed by the more advanced MAST machine in 2000. We continue to lead he way in spherical tokamak research, with the MAST Upgrade experiment due to launch in 2020.

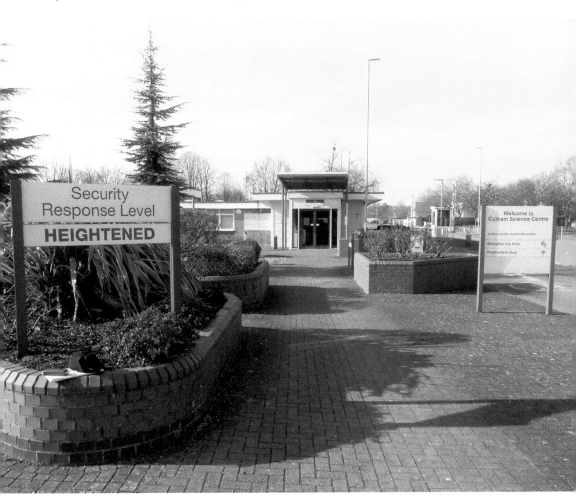

Heightened Response Level.

This last sentence indicates that the website was slightly out of date when I looked at it.

My dictionary defines tokamak as 'a toroidal reactor used in thermonuclear experiments, in which strong axial magnetic fields keep the plasma from contacting the external walls'. That should make everything clear.

Sweet City with her Dreaming Spires

Millions of words have been written to describe the architecture of Oxford, which is often claimed to be Britain's premier university city. The heading of this chapter particularly caught the public's imagination and is often quoted. The words were written in 1865 and come from a poem by Matthew Arnold entitled 'Thyrsis'. It describes the view of the city from Boars Hill, which is just outside Oxford. The poem includes:

Humid the air! Lifeless, yet soft in spring,
The tender purple spray on copse and briers!
And that sweet city with her dreaming spires,
She needs not June for beauty's heightening.

The photograph is of Magdalen College, one of the city's great buildings.

There is so much that can be said about Oxford that it is hard to know where to start. The city justifies whole books and, of course, such publications are available. The city has Anglo-Saxon origins and in the tenth century it was a frontier town between the kingdoms of Mercia and Wessex. It did not welcome the Danes and a considerable number of them were massacred in 1002. The Danes got their revenge by sacking the town two years later. Following this it was very badly damaged by the invading Normans in 1066.

During the English Civil War Oxford was the site of the court of Charles I after he had been forced to leave the capital. Some years later Charles II moved there for a time in order to escape the plague that was devastating London and much of the country.

The two journeys in this book terminate in Oxford and Cambridge. What are the two cities most famous for? Most British people instinctively say universities and many people around the world would give the same answer. Oxford is the oldest of the two and quite a few of them, though not those having Cambridge connections, would say that it is the most prestigious. Its origins lie in the twelfth century and it is the oldest English-speaking university in the world. It consistently ranks very highly in various rankings of the world's universities.

Oxford University is made up of thirty-nine semi-autonomous colleges, six permanent private halls and a range of academic apartments. All of the colleges are self-governing institutions and all the students are member of a college.

A great number of very successful and famous people from around the world have Oxford connections and this is true in many walks of life. At the time of writing Britain has had fifty-five Prime Ministers and twenty-eight of them were educated at Oxford. In the case of thirteen it was at Christ Church College. It seems that for a person with political ambitions this is the college to aim for.

In the field of sport Sir Roger Gilbert Bannister CH, CBE, FRCP deserves special mention. He obtained his degree at Exeter College and became a junior doctor at St Mary's Hospital in London. On 6 May 1954 after a morning's work at the hospital he took the train to Oxford, and in the evening became the first person in the world to run a mile in less than four minutes. He went on to achieve great success as a neurologist and was prouder of this than of his exploits as an athlete. He was for a time Master of Pembroke College, Oxford.

It has not always been sweetness and light. At times there has been bad feeling or worse between the university people in education and the town people. This divide became known as town and gown. In the past there was a tradition of celebrating and perhaps inebriated undergraduates knocking off the helmets of police constables. Some saw this as harmless fun, but others resented what they felt to be privileged Hooray Henrys misbehaving at the expense of hard-working citizens who did not enjoy their unearned advantages. In the distant past it was much worse and there were serious riots and fatalities. One must be cautious in detailing events so long ago, but it is believed that Cambridge University was established in 1209 by scholars leaving Oxford following the lynching of two of their number. It is further claimed that ninety-three people died in a town vs gown riot in 1355.

Education features prominently in Oxford's economy but there is much more. However, some of it might be termed spin-offs. Publishing features, particularly the Oxford

University Press. There have been a number of very successful science-based companies and enterprises. Oxford had a notable part in the extraordinarily swift development of the Oxford University–Astra Zeneca vaccine to fight Covid 19.

Motor vehicles have been built at Cowley on the eastern edge of Oxford since 1914. It was originally Morris Motors, which in 1952 became part of the British Motor Corporation (BMC). This in turn became part of the ill-fated and strike-bound British Leyland. For many years Cowley produced a very large number of vehicles and employed a very large number of workers. Part of the site now assembles Mini cars under the ownership of BMW of Germany. Morris Motors was founded by William Morris, who became a noted philanthropist. He became Viscount Nuffield in 1938 and among many other things he founded Nuffield College, Oxford. This was Oxford's first co-educational college. He was the epitome of the self-made man. He left school at the age of fifteen and a year later he started his first business, which was repairing bicycles.

As might be expected Oxford is a great draw for visitors and tourists. There is much to do and see, including museums and galleries, parks and gardens, theatres and shopping. There is a plethora of beautiful and interesting buildings (some with dreaming spires) and the rivers are a great attraction. The Cherwell joins the Thames at Oxford and the city is noted for boating, punting, riverside walks, riverside pubs and generally having a good time.

Magdalen College.

As well as happy memories of adult visits to Oxford I have a particular reason for looking back fondly on childhood ones as well. My father's cousin and her husband lived there and we saw them from time to time. As was the then custom I called them Aunt Nance and Uncle Vic. Nance made splendid teas but that was only one of the reasons for my happy memories. Shortly after we arrived she would take me to one side and say 'I know that your Uncle Vic won't give you anything so here's half a crown'. Shortly before we left Uncle Vic would take me to one side and say 'I know that your Aunt Nance won't have given you anything so here's half a crown'.

Journey's End: Oxford Station

As mentioned in the last chapter Matthew Arnold referred to Oxford as that sweet city with her dreaming spires. It is safe to assume that he did not have in mind the green structure in the photograph accompanying this chapter. An obvious and facetious reason for this is that it was completed in 2001 and Matthew Arnold died in 1888. Nevertheless, the description is still far from being appropriate. It is, though, in my view at least, rather attractive. It rises from the roof of the Said Business School, which is close to the station on the right side of the train.

This is the business school of the University of Oxford and is part of Oxford's Social Sciences Division. The Oxford Centre for Management Studies was founded in 1865 and after a previous change of name, in 1996 part of it was rebranded as the Said Business School. The name is a tribute to the Syrian-Saudi financier and businessman, Wafi Said, who very generously endowed it.

The building, in my view, blends nicely with its surroundings and, again in my view, this is true of many of Oxford's modern buildings. It is built on the former site of the Rewley Road Station, which was closed to passenger traffic in 1951. The goods yard was closed in 1984 and cleared in 1998 to make room for the present building. When operating, the station was the terminus for the line from Cambridge via Bletchley. Long before the railways were dreamt of it was the site of Cistercian monastery.

Oxford Station is half a mile west of the city centre and it is reached very shortly after passing the disused Church of England Osney Cemetery. This was opened in 1848 and it is now closed to new burials. It is interesting to note that in 1855 new burials were forbidden at all Oxford city churches, apart from existing vaults. Close to the line at this point are the Grade II listed remains of Osney Abbey. All that is left is rubble and a timber-framed stone archway. The abbey was dissolved in 1539 but created a cathedral. The building deteriorated into a state of ruin, starting in 1545.

If you follow the line described in this book your journey will end at Oxford Station. However, there are many other possibilities. Some trains from London Paddington go on Worcester and Hereford, and Oxford is on the north/south cross-country route from Manchester and Newcastle via Birmingham and Reading to Southampton and Bournemouth. Local trains go to and from Reading, Worcester and Banbury. Since 2016 fast and efficient services have run to and from London Marylebone via Bicester. It is a worthy alternative to the route described in this book. The Great Western Railway opened in Oxford in 1844 and it is a busy station.

The inspiration for Journey's End in the heading of this chapter comes from the title of the well-known and very successful play by R. C. Sheriff first performed in 1928. It

had the then twenty-one-year-old Laurence Olivier in the leading role. It has been adopted for the screen a number of times, most recently in 2017. The plot is a very bleak story of officers serving in the trenches during the First World War. It is semi-biographical because Sheriff took part in the conflict and was severely wounded at Passchendaele in 1917. It can be safely predicted that your journey will be infinitely more enjoyable than Sherriff's. However, he would have been happier to reach his journey's end.

Said Business School.

LONDON TO CAMBRIDGE

Liverpool Street Station

In the opinion of the writer, perhaps not universally shared, the street entrance to Liverpool Street Station is more visually attractive than the street entrance to Paddington. In this respect it is mid-table among the London termini. Surely the crown must go to St Pancras, which was built for the Midland Railway.

The names of two of London's great stations have an indirect connection with the names of two of Britain's Prime Ministers. One is Waterloo, which was named after the Duke of Wellington's 1815 victory over Napoleon. He was Prime Minister from 1828 to 1830 and for twenty-six days in 1834. He was a great general and a great man, but not a great Prime Minister. Among other things he is remembered for participating in a farcical duel while occupying No. 10 Downing Street. Furthermore, he shared two mistresses with Napoleon, though not at the same time. It is widely believed that one of the ladies completed a hat trick by having a child fathered by the Czar of Russia.

The other Prime Minister was Robert Jenkinson, 2nd Earl of Liverpool. He held the office from 1812 to 1827 and it only ended because he suffered a stroke. He was just forty-two when he was appointed and the country has not had a younger Prime Minister since. It has, though, had several younger ones before. They include William Pitt the Younger, who was only twenty-four at the time that he was appointed. Liverpool Street was named after the Prime Minister, and so indirectly was the station.

Liverpool Street processes almost twice as many passengers as Paddington, and it is the third busiest station in the United Kingdom. The two busier ones are Waterloo and Victoria, which are also in London. It serves a significant area in the East of England. The lines include the West Anglia Line to Cambridge, which is the subject of this part of the book, and the Great Eastern Main Line to Norwich. Other destinations are reached on various commuter lines and there is the Stansted Express service to Stansted Airport. Express trains go to Harwich International, where they link with ferries to the Hook of Holland. The service to Cambridge is operated by Greater Anglia. Liverpool Street links to the underground service and is traversed by the Circle, Central, Hammersmith and City and Metropolitan lines.

The station opened in 1874 as the London terminus of the Great Eastern Railway, and in doing so it replaced Bishopsgate, which had previously fulfilled this role. As often happens with major development projects the work caused distress to a considerable number of people. Around 3,000 were displaced and a further 7,000 were evicted. This was in order to build the station and the lines leading into it. To compensate for this disruption Parliament required the company to run daily, low-cost, workmen's trains.

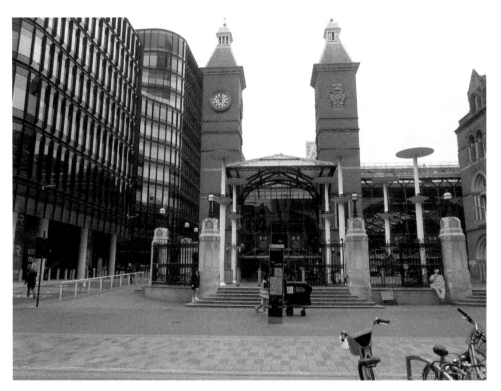

Entrance to Liverpool Street Station.

When the station opened it had ten platforms. Eight of them were used by suburban trains and two by main line trains. After a few years the capacity of the terminus was under pressure from the weight of the traffic. An Act of Parliament allowed the company to expand it eastwards by building eight extra lines and platforms, and this was completed in 1895. The station then for a while had more platforms than any of the other London stations. This time Parliament required the company to rehouse the displaced tenants. The station was extensively redeveloped in the late 1980s.

Liverpool Street Station has three times suffered from violence and destruction. On 13 June 1917 twenty German bombers targeted London resulting in 162 deaths and 432 injured citizens. Three of the bombs went through the station's roof and fifteen of the dead and sixteen of the injured were at the station.

In 1993 the Provisional IRA planted a truck bomb in nearby Bishopsgate and the blast damage reached the station. Then in July 2005 it was the turn of Islamist suicide bombers. Three bombs were exploded on tube trains and one on a London bus. One of the tube train bombs exploded on a train that had just left Liverpool Street on the way to Aldgate. As well as the bombers, fifty-two people were killed in all. Seven of them were in the train that had just left Liverpool Street.

The station houses a large marble memorial honouring more than a thousand Great Eastern Railway employees who were killed in the First World War. There are also plaques honouring Field Marshal Sir Henry Wilson and Captain Charles Fryatt.

The awful number of names on the marble memorial reinforces the horror at the scale of the slaughter in the war. It is worth noting that it was not just the dead who were victims.

There were also many physically injured and mentally scarred who were not included. The employees of other railway companies were also dreadfully affected. By some measures LNWR was the country's biggest company and in 1913 it employed 111,000. The war memorial outside Euston Station was erected 'in grateful memory of 3,719 men of the London and North Western Railway Company who for their country, justice and freedom served and died in the Great War 1914–19.'

The plaque honouring Field Marshall Wilson was placed following an atrocity. He was assassinated on 22 June 1922. He was of Irish origin and had been very prominent in the war and afterwards. At the time of the killing he represented a Northern Ireland constituency as a Unionist MP in the UK Parliament. He had the distinction of unveiling the memorial at Liverpool Street Station, then was shot on his doorstep when he returned home. His killers were IRA members and were rapidly apprehended by the police and a crowd. Two policemen and a civilian were injured while doing so. The two assassins, who had both fought for Britain in the war, were hanged a few weeks later.

Charles Fryatt was the captain of SS *Brussels*, which was owned and operated by the Great Eastern Railway. On 28 March 2015 he tried to ram a German U-boat, which was about to torpedo his ship. The U-boat crash dived and escaped. A year later on a different mission his ship was surrounded by German destroyers and he was captured. He was put on trial and rapidly convicted and executed. The Germans claimed that he had sunk the U-boat, which was not true. Their dubious and legalistic case was based on the claim that he was not in the military and should have behaved as a non-combatant. The execution caused outrage in Britain and in other countries too.

After the war Fryatt's body was exhumed and returned to Britain for an honourable funeral service and burial. The band of the Great Eastern Railway participated in the service that was

Kindertransport sculpture.

held in St Paul's Cathedral. Afterwards the coffin passed through Liverpool Street Station on its way to Upper Dovercourt near Harwich, which was to be its final resting place. Fryatt's remains were one of only three repatriated to Britain after the war. The others were those of Edith Cavell and the Unknown Warrior. The last of these were reinterred in Westminster Abbey.

A visit to Liverpool Street Station should include a look at the Kindertransport Sculpture. It is just outside the main entrance in the small area leading to Liverpool Street. A photograph of it is included in this chapter. It is cast in bronze and depicts three girls and two boys of various ages. They are at the end of a railway line and holding their cases. The youngest girl is clutching a toy. The sculptor was Frank Meisler and it was unveiled in 2006. The work was commissioned by World Jewish Relief and the Association of Jewish Refugees.

The sculpture is beautiful, thought-provoking and heartrending. It is dedicated to the 10,000 unaccompanied children, mainly Jewish, who escaped Nazi persecution by coming to Britain shortly before the Second World War. They came mostly from Germany and Austria. Many of them passed though Liverpool Street Station and most of them never saw their parents again.

After recounting all these tragedies it is opportune to move to something lighter. Liverpool Street is one of four stations featured in the UK version of the board game Monopoly, the others being Fenchurch Street, Kings Cross and Marylebone. The game has given pleasure to millions and continues to do so. Liverpool Street has indirectly contributed to that. One wonders why these particular four stations were chosen.

Andaz Hotel: Formerly the Great Eastern Hotel

Two names are listed in the heading but during its life the hotel has operated under three. It opened in 1884 as the Great Eastern, then in 1908 it changed to Liverpool Street and this was its name for most of its existence. Since 2006 it has been owned by Hyatt and has traded under the Andaz brand.

Like many of the Victorian railway companies Great Eastern correctly thought that it made business sense to have a major hotel adjacent to its London terminus. It was designed by Charles Barry Jr and Edward Middleton Barry. They were the sons of Sir Charles Barry, a man best known for designing the present Houses of Parliament after the disastrous fire of 1834. The original hotel only had twelve bathrooms to serve 160 bedrooms, which perhaps says something about the Victorians' attitude to cleanliness.

The present Andaz Hotel is five-star rated and Grade II listed, and is an attractive red-brick Victorian building. It is large, having 267 rooms including fifteen suites. Teetotal guests no doubt appreciate the free non-alcoholic minibars. Additionally they may join the drinkers in liking the seven restaurants and bars.

The Abercorn rooms were added in the 1890s and the hotel was extensively renovated between 1899 and 1901. It is particularly interesting to note that in the early part of the last century fresh seawater was brought in daily by train. Hotel guests used this for bathing. I am not aware of this practice being carried on anywhere now. The hotel was renovated again in 2000 and at this time it was owned by Sir Terence Conran.

A particularly admired feature of the hotel is the Masonic Grecian Temple on the first floor. Such things in hotels were and are unusual, and the hotel had two of them. One had an Egyptian

theme, but this no longer exists. The Grecian-themed one was built in 1912. The chairman of the railway company was a Mason, which perhaps goes some way to explaining it.

I have not seen the temple but photographs show that it is remarkable and magnificent. It is windowless and reached by a winding staircase. Entrance is through heavy studded doors and a spacious mahogany-panelled anteroom. There are bronze candelabras and twelve types of marble are used on the checkerboard floor. The ceiling, which is a blue and gold dome, has a five-pointed 'blaze star' and zodiac signs. It contains an organ and hand-carved mahogany chairs. Masons might notice discrete Masonic insignia. It comes at a cost, a considerable cost you might think, but the temple is available for hire.

A plaque in the street records that from 1247 to 1676 the hotel was on the site of Bethlem hospital. This has moved several times since then and it is now a modern psychiatric institution, but its past has been very different. The name of the hospital became corrupted and Bethlem gave us the word 'bedlam'. This has very negative connotations and it means uproar and confusion. The unfortunate inmates of the hospital sometimes suffered badly. Should we blame out forebears? Perhaps, but let us reflect on the opening words of *The Go Between* by L. P. Hartley: 'The past is a foreign country. They do things differently there'. It contains much wisdom, so let us not rush to judgement. We might even ponder what future generations will think about us.

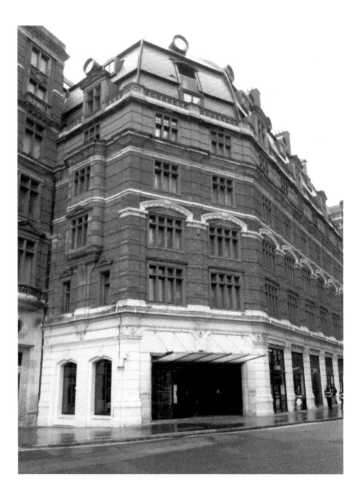

Front of Andaz Hotel.

Bethnal Green: The Good, The Bad and The Ugly

Many years ago a family friend remarked to me that London's East Enders were among the very best in the country, but that a few of them were among the very worst. I think that he had a point, though emphasising that the good greatly outnumber the bad. Bethnal Green Station is only just over a mile from Liverpool Street and firmly in the 'old' East End of London. With my friend's observation in mind this chapter records the stories of three of Bethnal Green's very best and two of its very worst. The very best are the three Beverley sisters and the very worst are the identical Kray twins.

The Beverley sisters were very talented close harmony singers and by many accounts they were for a long time the country's highest paid female entertainers. Furthermore, their career was extraordinarily long. They performed on the radio in 1944 and were at their peak in the 1950s and 1960s. Their last appearance at a live event was in 2009. In 2002 the Guinness Book of Records said that they were the world's longest surviving vocal group without a change in the original line up.

The sisters were born and grew up in Bethnal Green, and by general agreement they were very nice as well as very talented. Joy was born on 5 May 1924 and twins, Babs and Teddie, were born on 5 May 1927. They were extremely close, so it seems appropriate that the three of them shared a birthday. They looked alike, wore the same outfits in their private lives as well as on stage, kept their hair the same way and had the uncanny knack of finishing each other's sentences. What is more they lived in adjacent houses, even after marriage.

Joy Beverley's second marriage was to the footballer Billy Wright. He captained England no fewer than ninety times. It was a good match because he was a very nice man, which I can confirm from personal experience. He did not mind the closeness of his wife to her two sisters. There are obvious similarities with the marriage of Victoria Adams (Posh Spice) to David Beckham.

The sisters' very long career included successes with records, many television appearances and a vast number of live performances. They appeared in the Royal Variety Performance in 1952, 1972 and 1978.

I had the privilege of hearing them at the London Palladium in 1978. It was a wonderful, women-only, televised event to commemorate the fiftieth anniversary of all women getting the vote in the UK. There were a number of superb performances, but I remember them especially. Another recollection of the evening is that I told Margaret Thatcher, who was leader of the opposition at the time, where to go and she did. At the end we both took a wrong turn and went down a corridor that led to a dead end. She turned to me and said 'Is there really no way out?' I told her and she thanked me. We both then walked out.

So much for the good. Now for the bad. Ronnie and Reggie were the identical Kray twins. They were born in nearby Haggerston and moved to Bethnal Green in 1938 when they were four. Between the late 1950s and 1967 they were vicious gangsters operating in the East End of London. Their crooked organisation was known as 'The Firm'. Reggie was heterosexual and Ronnie was homosexual, though in his latter years he said that he was bisexual.

The twins used a lot of violence and ruled by fear. For many years they engaged in murder, armed robbery, protection rackets, intimidation and other crime. In addition, they become famous for prominent, non-criminal activities. These included owning a West End nightclub. Many show business celebrities and other famous people patronised it. The

The writer at Bethnal Green Station.

twins loved the publicity and many stars later came to regret having been photographed with them.

Towards the end of their infamous careers Ronnie shot and killed George Cornell, who was a member of the rival Richardson gang. He walked into the Blind Begger pub and did it in full view of the barmaid and the patrons. They all saw it and most knew who he was, but they were all too frightened to come forward. By then Ronnie was suffering from paranoid schizophrenia. The two of them probably killed or had killed Frank Mitchell, who was sometimes known as the 'mad axemen'. However, they were later acquitted of the charge.

In October 1967 Reggie killed Jack 'The Hat' McVitie. He did it by twisting a knife in his neck. McVitie was a member of The Firm who had not carried out a murder for which he had been partly paid in advance.

The murder of McVitie strained the loyalty of some in The Firm. They thought that the punishment was too harsh and it made them wonder about their own vulnerability. Soon afterwards the police managed to bring various charges. Criminals were promised special consideration if they co-operated. Courageously the barmaid at the Blind Beggar took a new identity and agreed to give evidence.

In March 1969 both the twins were convicted and sentenced to life imprisonment with the recommendation that they must each serve at least thirty years. In 1979 Ronnie was transferred to the high-security, psychiatric hospital at Broadmoor. He married twice while there. Each marriage ended in divorce. Reggie married in 1965. His wife committed suicide two years later.

Ronnie died in Broadmoor in 1995. Reggie was released on compassionate grounds eight weeks before he died of bladder cancer in 2000. Both twins were buried with their

parents and older brother Charlie at Chingford. Despite all the things that they had done their funeral processions were watched by large numbers of applauding people.

The title of this chapter includes *The Good, the Bad and the Ugly*, which is the title of a 1966 film starring Clint Eastwood. The good and the bad have featured but where is the ugly? Well please look at the photograph, which shows the writer of this book. There is the answer.

The Regent's Canal

The line crosses over the Regent's Canal slightly more than half a mile past Bethnal Green Station. The photograph shows the view from the left side of the train.

The canal links the Paddington Arm of the Grand Union Canal with the River Thames at Limehouse. It is just over 8.5 miles long and incorporates three tunnels, the longest being the Islington Tunnel, which has a length of 969 yards. The route runs along the northern edge of Regent's Park and bisects London Zoo. It is stretching the imagination almost to breaking point, but it could be likened to an inner-London canal version of the North Circular Road. The canal was built before the railway age and a principal objective was to help take goods and material from the River Thames and North London up to the Midlands. It brought things the other way too, of course.

Work started in 1812 and the first section was completed in 1816. The whole canal opened in 1820 when work on the second section was concluded. Financial difficulties delayed the construction and these were exacerbated by the embezzlement of funds by Thomas Homer, once the canal's promoter. He was sentenced to transportation. Another drain on funds was the cost of settling a dispute with a landowner.

Building the canal eventually cost £722,000, which was twice the original estimate. Major capital projects have a habit of costing more than planned. In my book *London to Birmingham by Rail* I tell how Kilsby Tunnel, then the longest tunnel in Britain, cost £300,000 rather than the projected £100,000.

The Regent's Canal was finished just a few years before the start of the railway age, and this meant that the anticipated profits were short-lived. It was initially heavily used, but commercial traffic declined and had virtually ceased by the 1960s. In the nineteenth century, there were serious plans to convert the canal into a railway but, as it is still there, it is stating the obvious to say that they did not come to fruition. In 1927 the Regent's Canal Company bought the Grand Junction Company, and together they became the Grand Union Canal Company. This was nationalised in 1948.

The canal is beautiful in parts and it has been called one of London's best-kept secrets. It is now used by pleasure craft and, in the summer months, a waterbus runs at hourly intervals from Maida Vale to Camden. The towpath is used by cyclists and walkers. Quite a few cyclists also use it for commuting. The London Canal Museum at Battlebridge Basin is worth a visit and so are the Camden Markets, which are located next to the canal. They contain an exciting collection of what seems like hundreds of stalls. Words to describe them would include 'quirky', 'modern' and 'way-out'. Unsuitable words would include 'upmarket' and 'traditional'. The stalls feature a vast array of such things as posters, cards, clothes, shoes, bags and music.

The famous architect John Nash was a director of the Regent's Canal Company, though his assistant John Morgan was appointed the canal's engineer. Nash was a friend of the

Prince Regent and he successfully asked his permission to have the company and the canal named after him. The nearby Regent's Park is also named after the Prince. It was Nash who built the much-loved Royal Pavilion in Brighton for him.

The Prince Regent, George Augustus Frederick, was the eldest son of George III and he ruled as regent from 1811 when his father descended into madness. The Regency lasted until his father's death ten years later, and he then ruled as George IV until 1830. He is fondly remembered as the patron of architecture and as a profligate collector of fine paintings, but history has not been kind to his memory. He was exceedingly extravagant, enormously fat and perpetually burdened by serious debts. He did not rule wisely and he was held in contempt by many of his subjects.

At the age of twenty-three, he went through a form of marriage with Maria Fitzherbert, who was six years older than him and a twice-widowed Catholic. The marriage was illegal because the Royal Marriages Act 1772 required the consent of the monarch. This was neither sought nor granted. Furthermore, the Act of Settlement 1701 prevented the spouse of a Catholic succeeding to the throne.

The parlous state of George's finances were an embarrassment and a scandal, and his father only agreed to help him on condition that he married his cousin, Caroline of Brunswick. His bride horrified him and they separated soon after the wedding. Among many other complaints he thought that she was unhygienic. George had a number of

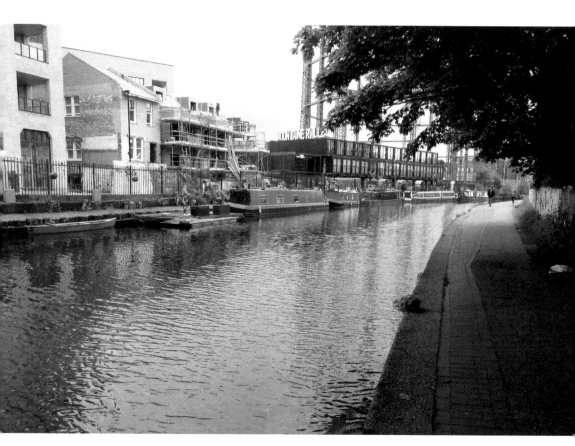

Westwards view of the Regent's Canal.

mistresses, both before and after the wedding. He also fathered a number of illegitimate children. It has been noted that many of his mistresses were grandmothers, so at least he cannot be accused of age discrimination. After nearly a quarter of a century apart, Caroline demanded to take her place as queen at George's coronation. The king's attempt to divorce her failed, but he did manage to keep her away from the coronation. The people very strongly supported Caroline.

On George's death *The Times* newspaper printed, 'There never was an individual less regretted by his fellow-creatures than this deceased King. What eye has wept for him? What heart has heaved one unmercenary sorrow? ... If he ever has a friend – a devoted friend in any rank of life – we protest that the name of him or her never reached us'.

If you are feeling charitable as you cross the Regent's Canal, you might reflect that Maria Fitzherbert was the love of George's life, and that he died with a miniature portrait of her hanging around his neck. Had their marriage been recognised, his life and his reign might have turned out much better, but of course they might not. We will never know.

Tottenham and Geometric Frustration

Tottenham Hale Station is 6 miles from Liverpool Street. As the name suggests it is in Tottenham, which is in north-east London. The area is now part of the London Borough of Haringey.

More than 900 years ago a Mr Tota was a local farmer and it is believed that the word Tottenham is derived from his name. The settlement of Tota's Hamlet was recorded in the Domesday Book in 1086 as Toteham. It is a fanciful thought but one wonders what Mr Tota would think of his hamlet and its surrounds if he were to visit it now.

As happened to many places the area developed with the coming of the railway. In the 1870s the Great Eastern Railway introduced workmen's trains and special fares on its Enfield and Walthamstow branch lines. This led to housing development and workers commuting into the centre of London. In more recent times the area has become noted for its ethnic diversity and in the 2011 census only 22.3 per cent of the population of 129,237 was classed as White British.

Sadly, Tottenham is remembered for two very serious riots. The first of them was on the Broadwater Farm Estate in October 1985. It was triggered by the death of a woman who succumbed to heart failure during a police search of her home. It was at a time of high tension shortly after the even more serious Brixton riots in South London and riots in other parts of the country. PC Blakelock was murdered in the Tottenham riots. He was struck forty times with weapons and a knife was embedded in his neck. A police sergeant was awarded the George Medal for his efforts in trying to shield him. No one was ever successfully prosecuted for the murder. Fifty-eight other policemen suffered injuries, two of them from gunshot wounds.

The second major riot took place in August 2011. It was triggered by the shooting of a local man by the police. The circumstances of how this happened are not absolutely clear, but the consequences were very serious. There was widespread arson, looting and damage to property. The riots started in Tottenham but they spread to other places in London and around the country. Both of the 1985 and 2011 Tottenham riots were triggered by hostility to the police. Whatever the grievances, real or imagined, the riots could not possibly be

justified and were a stain on Tottenham's reputation. Apart from anything else the poor and vulnerable figured prominently on the list of those disadvantaged by them.

It takes a lot of people to make a riot, but in 1909 just two persons committed murders and a robbery that have passed into the annals of crime. It became known as the 'Tottenham Outrage'. Two Latvian anarchists robbed a wages clerk and pursued by the police and local citizens they fled across the marshes and the River Lea. On the far bank they hijacked a tram and continued their escape. However, they were pursued by the police and others who commandeered another tram.

Eventually the first tram was stopped and the robbers continued on foot, but the police and public spirited citizens continued the chase. The robbers fired wild shots at the forces of law and order and their supporters, and in doing so they killed a policemen and a boy of ten. In addition their actions wounded a number of others. All this was done while they were running and firing back. They must have had a lot of bullets. What incredible bravery was shown by the police and the good people of the area. The murderers were undoubtedly destined to be executed, but in the end the hangman's services were not required. They were eventually cornered and to avoid arrest they shot themselves. Well done the police and well done the people of Tottenham. We could have done with having them around when the riots took place.

At this point you might reasonably be wanting answers to three questions:

- What about Tottenham Hotspur?
- What does the photograph show?
- What on earth is geometric frustration and what has it got to do with Tottenham?

The three answers are linked. Let us start with Tottenham Hotspur Football Club. It is sometimes said to be one of England's big six clubs, the others being Arsenal, Chelsea, Manchester United, Manchester City and Liverpool. It is not a coincidence that the owners of all six clubs are very rich. Space limits what can be said but the following should be interesting. The club has a great history and is (or at least has been) admired for its attractive, attacking style of play.

It was formed by a group of schoolboys in 1882. Schoolboys grow up and the club changed and prospered. It turned professional in 1895 and won the FA Cup in 1901. This was achieved when it was playing in the Southern League. It is the only time since the Football League was created in 1888 that the trophy has been won by a team not playing in it or the Premiership. Tottenham beat Sheffield United in the replay after drawing at Crystal Palace in front of a crowd of more than 110,000 spectators. The FA Cup was taken more seriously then than it is now.

Created by a local baker in the late nineteenth century, Tottenham cake is a distinctive local delicacy. The cup triumph was celebrated by giving local children a piece of it.

Tottenham joined the second division of he Football League in 1908 and over the years it has won many trophies. The first division was won in 1950/51 and again in 1960/61, and there have been seven further FA Cup triumphs. The most recent was in 1991. The UEFA Cup Winner's Cup was won in 1963 and lower ranked UEFA competitions have been won twice. The League Cup has been won four times. The 1960/61 League/FA Cup double was the first time that this had been done since 1896/97 when it was achieved by Aston Villa.

The club's two greatest periods were the early 1950s under manager Arthur Rowe and 1958–64 under Bill Nicholson. Rowe is remembered for the style of play dubbed 'push and run'. Nicholson is remembered for success, attractive play and managing great players. Before managing Tottenham Nicholson played for them. He was a half back and appeared

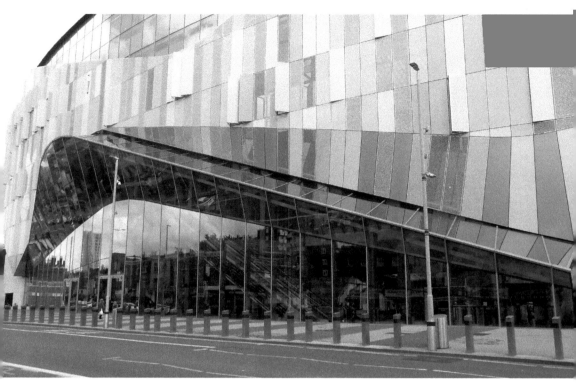

Tottenham Hotspur Stadium.

just once for England. He scored just nineteen seconds into the game. Despite this he was not selected again.

There are so many stories that can be told. Steve Perryman played 854 games between 1969 and 1986. Les Allen scored forty-nine goals in the 1986/87 season and of course Jimmy Greaves scored no fewer than 266 goals in 380 games. He also scored forty-four goals in fifty-seven games for England. Despite this and being in great form for Tottenham he was not selected after the age of twenty-six. In more recent times they have had many great players including Gareth Bale and the goalscoring and inspirational England captain Harry Kane.

Supporters of a superstitious disposition were looking forward to the 2020/21 season. This was because many of the club's triumphs have occurred in years ending with the number one. This was true of both league championships and five out of the eight FA Cup wins. It did not come to pass. Tottenham finished seventh in the premiership and the manager, José Mourinho, was sacked in April. Money did not seem to be a problem. If reports are to be believed (always a sensible qualification) some players banked hundreds of thousands of pounds a week and Mourinho got a multi-million pound pay off. There is a lot of money and greed at the upper levels of football, and not just at Tottenham.

Tottenham were and are a great club. Furthermore, they will probably continue to be a great club. However, it is a long time since they actually won anything of note – more than sixty years since their last league top position and more than thirty years since their last FA Cup win. They have never won the European Cup or its successor competition the UEFA Champions League. There have been many good seasons, but by Tottenham's very high standards not high enough and not enough of them.

Tottenham took possession of their ground, known as White Hart Lane, in 1899 and played there until the end of the 2016/17 season. In the latter years it was an all-seater stadium with a capacity of 36,284. This was not enough so the new Tottenham Hotspur Stadium was built on the same site and some surrounding land. It is a photograph of this that appears in this chapter.

To use a modern and not particularly grammatical phrase the new stadium is quite something. It has an all-seating capacity of 62,303, which makes it the third largest football stadium in England. The two bigger ones are Wembley and Manchester United's Old Trafford with a seated capacity of 90,000 and 74,000 respectively.

The fans are seated close to the pitch. The stadium is an asymmetrical bowl shape and it is all designed to intensify the noise made by the supporters and enhance the atmosphere. As only a small minority of the spectators are likely to be supporting the visitors this is quite an advantage and, some might argue, perhaps rather unfair. Others, probably the great majority, would think that this is a silly observation. All leading clubs try to maximise home advantage.

There is a Desso Grassmaster hybrid grass pitch for football. However, this can be retracted to expose a synthetic turf surface underneath. This is for American NFL football, concerts and other things. The pitch is lit by 324 LED floodlights arranged in fifty-four groups of six.

The northern end of the stadium has nine floors above the basement, and the single-tier southern end has five floors. To put it mildly corporate hospitality is not neglected. The exterior of the stadium features different claddings of glass, metal panels and pre-cast concrete. If you like that sort of thing then that will be the sort of thing that you like.

White Hart Lane Station is very close to the Tottenham Hotspur Stadium and it is on the Lea Valley Line from Liverpool Street. A good view of the stadium can be had from it. The line to Cambridge is not far away, but disappointingly the stadium, which is on the right side of the train, cannot be seen from it. This is of course unfortunate. The reason is the phrase in the title of this chapter, namely geometric frustration.

The laws of geometry mean that a continuous obstruction close to the line prevents anything other than an extraordinarily tall structure being visible from the train, even if it is not too far away. The stadium is tall but not tall enough. I found it frustrating and readers of this book may feel the same way.

It seems appropriate to end this chapter with some words from a relevant and much-loved music hall song published in the early 1890s. It is a cockney song entitled 'If it Wasn't for the' Ouses in Between'. It was written by Edgar Bateman and made famous by the cockney performer Gus Elen. The following is part of the chorus

Wiv a ladder and some glasses,
You could see to 'Ackney marshes,
If it wasn't for the 'ouses in between.

The M25 Motorway

The line crosses the M25 motorway shortly after leaving outer London and shortly before it reaches Waltham Cross. The photograph is taken from a point very close to where this happens. Traffic in both directions was moving freely but as many readers will undoubtedly

know this is by no means always the case. Some might think that it is not usually the case, at least in the parts that they use most frequently.

The connection is very tenuous, ridiculously so some may say, but the words of Jane Austen come to mind. In 1813 she wrote, 'It is a truth universally acknowledged that a single man in possession of a good fortune must be in want of a wife. In more recent times she might have observed that It is a truth universally acknowledged that one of the world's greatest cities must be in want of a good orbital road'.

The story starts as long ago as 1905 with recommendations by a Royal Commission on London Traffic. These included roads similar to what we now call the North Circular and South Circular. Some evidence to the committee proposed another ring further out. By 1924 much of the North Circular was under construction and by 1935 streets were joined to form the tortuous South Circular. This was decidedly unsatisfactory because, as existing streets were linked together, there were many junctions and it dd not link with the North Circular in the west. The roads were nothing like motorway standard. In 1934 there were 2.4 million vehicles in Britain; there are around 40 million now.

The first coherent proposal for a proper orbital road round Greater London was made in 1934 by the Engineer to the Ministry of Transport. It was to be 18 to 20 miles out from Central London, and had many similarities to the eventual route of the M25. There were further proposals in 1944 and up to 1966. None of them were actioned.

The one that was built was announced by the Minister of Transport in 1975 and it was to incorporate some high-quality roads that had been built in the early 1970s. The route was 117 miles long and included a new bridge over the River Thames, a new tunnel under the river and the utilisation of an existing tunnel. These were technically not part of the motorway. The M25 was opened in sections and the ring was completed in 1986. As you look you may see free-flowing traffic, though it will undoubtedly be busy. On the other hand you may see slow-moving traffic or a complete stoppage. If it is the latter, you may understand why the M25 is sometimes called the biggest circular car park in Britain.

It is another truth universally acknowledged that British motorways are not built to an adequate specification, and the M25 was no exception. It was designed for a maximum of 88,000 vehicles per day, but by 1993 it was handling 200,000 vehicles per day. It is now considerably more. Consequently it has been regularly widened and improved – a process which is continuing. It would have been cheaper and better to have been more ambitious, but as a taxpayer I can understand why this did not happen.

The M25 has numerous fixed cameras in each direction, both clockwise and anticlockwise. You may be relieved to know that they are not all used for enforcement purposes, though it might sometimes seem like it. In addition there are frequently temporary enforcement cameras because of roadworks. Prosecutions for speeding are becoming harder to avoid because of the sneaky practice of recording average speeds between fixed points. As a law-abiding and safety-conscious citizen you will no doubt welcome this, but it might be hard to be pleased when you open an envelope and find a 'Notice of Intended Prosecution'.

Having got this off my chest but feeling grumpy, I will bring in the Dartford Crossing. This is the Queen Elizabeth II Bridge that crosses the River Thames in a clockwise direction and two tunnels that take traffic under the river the other way. The tunnels were open before the motorway was built and the bridge, which carries up to 150,000 vehicles a day, was completed in 1991. Since 2014 it has not been possible to pay the toll in cash at the bridge. Payment must now be made online, by text message, by phone or with a pre-pay account. It is another step in the relentless move to phase out cash and make life more troublesome for us. On a more cheerful note the motorway, which is 117 miles long, was

formerly woefully deficient in service areas but now has four of them. This is just under one every 30 miles on average.

Still feeling grumpy I will mention that like other motorways parts of the M25 are now so-called smart motorways, and further large sections are in the course of conversion. This means the abolition of the hard shoulder in some cases, and the use of the hard shoulder for running traffic for part of the time in other cases. Refuge areas for vehicles in trouble are provided at regular intervals. A high degree of monitoring by cameras is promised and hopefully delivered, though there have been worrying and dangerous failures. Lanes are closed when necessary and this is communicated to drivers by warning lights.

There are obvious advantages in increasing the capacity of the motorway and regulating the flow of traffic. As a taxpayer I welcome the monetary savings. Nevertheless, many people (of which I am one) think that the abolition of the hard shoulder for some or all of the time is inherently dangerous. I write this having been trapped behind a broken-down car on what was once the hard shoulder. It was between refuge areas and it was a terrifying experience. Yet another grumpy observation – governments have a bad habit of hiding bad policies behind attractive titles. Who could object to 'SMART MOTORWAY'? I could for one.

A major issue is what will happen if and when a third runway is built at Heathrow Airport. The options are diverting the motorway, putting in a tunnel and putting a runway on a ramp over it. If the extra runway is built, whichever option is chosen will cause many years of disruption for users of the motorway. Also the new runway, when complete, would increase the number of passengers using the airport, the number of people working at it and

The M25 Motorway looking eastwards near Waltham Cross.

the number of vehicles using the M25. The country does need the extra airport capacity though.

An account of the M25 motorway would not be complete without some extraordinary facts. Here are three of them:

- The highest speed recorded by the police is 147 mph.
- An eighty-four-year-old man spent forty-eight hours trying to find the turn off that he wanted.
- The police detained an elderly lady cycling on it in the wrong direction.

Almost everyone has at least one M25 story and I have several, so this chapter ends with an account of the hobby of the father of one of my son's friends. In the early days of the motorway he would frequently drive the complete lap, trying to beat his best time. He made it an absolute rule never to break a speed limit. He did this many times, including at night. Sad isn't it?

Waltham Cross

Waltham Cross is just short of 13 miles from Liverpool Street and it is just after the M25 motorway, which was the subject of the last chapter. It is in the Borough of Broxbourne and stretches almost to Cheshunt in the north, which is the subject of the next but one chapter, and almost to Enfield in the south. It is in the south-eastern corner of Hertfordshire and as the crow flies just a mile from Waltham Abbey. This is in Essex and it is located exactly on the Greenwich Meridian. It follows that a short walk from Waltham Cross takes one from the western hemisphere into the eastern hemisphere. It sounds very impressive for someone trying to improve their fitness and achieve the recommended 10,000 steps a day.

The small town of Waltham Cross probably takes its name from the Eleanor Cross located in its centre, and it is this that is shown in the photograph. It is very interesting and of great historical significance. The cross is given due prominence later in this chapter.

Some places emanate warmth and friendliness, whilst others have the opposite effect. Others may disagree but I like to see myself as a kindly person, so I will not mention any places that have the latter effect on me. There is also the factor that I do not want to offend anyone who might consider buying this book. I will, though, say that I very quickly took to the town of Waltham Cross and what I saw of its people. During my visit it seemed that all of its residents were in the town centre and delighted to help with my enquiries. This phrase is sometimes used in connection with people assisting the police in somewhat dubious circumstances, but in the best sense it is what they did for me. I look forward to my next visit.

The town has a connection with the 2012 Olympic Games held in London. The White Water Rafting Centre adjoining the beautiful River Lea was the site of some of the events. If they dare to do so, adventurous members of the public can now take the rapids.

Notable residents include the great Victorian novelist Anthony Trollope, who lived in the town from 1859 to 1871. He was only sixty-seven when he died in 1882 and until the

age of forty-nine he worked full time as an employee of the Post Office, eventually at a very senior level. He was credited with introducing mailboxes to the streets of Britain. In the limited time that he had available he wrote ferociously. He had published forty-seven novels, forty-two short stories, five travel books, non-fiction books on Palmerston and Thackeray and an autobiography published after his death.

In addition to everything else that he did Trollope had political ambitions and he wanted to be a Member of Parliament. He was adopted as a Liberal candidate for the 1868 general election. The constituency was Beverley in the East Riding of Yorkshire. This seat had a terrible record of illegal and immoral behaviour, and every election since 1857 had been followed by a petition alleging corruption. It was widely believed that the votes of around 300 of the 1,100 electors could be bought.

Trollope finished last of the four candidates and the two Tories were elected in the two-member constituency. The notorious conduct during the campaign and the vote resulted in the disenfranchisement of the borough in 1870. Trollope was disgusted and never became an MP. He wrote a thinly disguised account of what had happened in his 1870 novel *Ralph the Heir*.

It should not be thought that Tory candidates were the only ones to engage in corrupt practices. In the same election one of two Liberal candidates at Cashel in County Tipperary paid £30.00 to each of twenty-five butchers in order to secure their votes. This was a very large bribe at the time. There were only 203 registered voters. As with Beverley the result was declared void and the constituency was abolished in 1870.

In 1868 voting was in public so everyone could see who had voted which way. This changed and many other abuses were curtailed by the Corrupt and Illegal Practices Prevention Act 1883. There was then no point in bribing electors because it was not possible to know if they actually voted as intended.

The town's Eleanor Cross is a tribute to the love of Edward I for his first wife Eleanor of Castile. It was an arranged marriage and Eleanor travelled alone from Spain to England when she was just ten. She married Edward, who was three years older, when she was twelve. Her first child was born when she was thirteen but the baby did not live long. The couple had between thirteen and sixteen children (the exact number is not known), but only five girls and a boy lived to adulthood.

Edward became king in 1274 at the age of thirty-seven. During almost the whole of his marriage, both before and after he became king, he was engaged in crusades, other wars and fighting insurrections. Eleanor accompanied him on many of them. They were a devoted couple and unusually for monarchs at the time there were no hints of mistresses or children out of wedlock.

Eleanor died aged forty-nine at Harby in Nottinghamshire on 12 November 1290. Her viscera (minus her heart) were buried in Lincoln Cathedral, her heart was buried at Blackfriars Monastery and her other remains were buried at Westminster Abbey.

Edward was devastated by his loss and he ordered that commemorative monuments be erected at each of the twelve places where her remains had rested overnight on their journey back to Westminster Abbey. This was done between 1291 and 1295 and they are known as the Eleanor Crosses.

They were located at Lincoln, Grantham, Stamford, Geddington, Hardingstone (now part of Northampton), Stony Stratford, Woburn, Dunstable, St Albans, Waltham Cross, Cheapside (in London) and Charing (close to Westminster Abbey and now known as Charing Cross). Only the ones at Geddington, Hardingstone and Waltham Cross remain.

The Eleanor Cross.

We just have fragments of the others. A replacement one at Charing Cross was erected in 1865.

The one at Waltham Cross was built by Roger of Crundale and Nicholas Dymenge. Sculpture was by Alexander of Abingdon. In 1721 oak bollards were put up to protect the structure from carriages. These were removed in 1757 and replaced by a brick plinth. There were restorations of the structure in 1832–34, 1885–92, 1950–53 and 1989–90. The original statues of Eleanor had become very weathered and they were replaced by replicas during the 1950–53 restoration.

As can be seen from the photograph the cross is tall, solid, well-preserved, impressive and a credit to the town. Time spent on a visit would not be wasted.

River Lee Country Park

Many years ago my geography teacher at Aylesbury Grammar School told the class that the country of Chile was a rather silly shape. It is very long and narrow and runs down much of the west coast of South America. I particularly remember the remark because my godfather was half Chilean. The recollection came to me when I looked at the River Lee Country Park on a map. Like Chile it is long and thin, and it runs from Waltham Abbey to Broxbourne. It incorporates part of the River Lea and strips of land on either side of it.

The Country Park can first be seen on the right side of the train shortly after leaving Waltham Cross Station and there are many sightings on the same side all the way up. The photograph was taken at a point just before Cheshunt Station.

It covers 1,000 acres, which is big. Young readers will probably think in metric terms, but older ones (and to be fair many younger ones too) will probably know that there are 4,840 square yards in an acre. 1,000 acres would cover a square that has exactly 1.25 miles on each of its four sides.

Why is a park that incorporates the River Lea called the River Lee Country Park? It is an understandable question. The Lee Navigation is a canalised river incorporating part of the River Lea. The river is sometime called the River Lee along the sections that are navigable.

The park is managed by the Lee Valley Regional Park Authority and there are no charges for entry. The area was once part of the River Lea flood plain. There were a good number of mature gravel pits and these account for many of the lakes within it.

One reason for a visit is that it is a superb place for a few hours' simple enjoyment. There are sculptures, children's play equipment, open spaces for games and picnics and other attractions. A notable one is a 500-metre-long dog agility course with jumps, high walks, etc. Fido should have a good time as well as children and adults. A visit to the Royal Gunpowder Mills should be both educational and enjoyable.

A second good reason for making a visit is to both study and enjoy the nature and the wildlife. There is a lot of it. I am not qualified to comment in detail so what follows draws heavily on the Country Park's website. It is very informative and I am grateful to it.

There are large expanses of reedbeds in Seventy Acres Lake, which is in the Fishers Green area. Wintering birds that might be seen include bittern and smew. The lakes and wetlands may host a wide range of ducks including gadwall and shoveller, as well as waders such as lapwing and snipe. With plenty of woodland you might hear the song of a nightingale. The chances of this are certainly higher than if you try to do so in Berkeley Square.

A feature of the park.

The environment is conducive to the success of birds such as whitethroat, yellowhammer, kestrel and barn owl, breeding lapwing and kingfisher. Waders passing through in spring and autumn include common sandpiper, green sandpiper and redshank. Winter visitors may include teal and wigeon. It is an excellent place to see different varieties of dragonfly.

Cheshunt

The last but one chapter describes Waltham Cross as a friendly place with friendly people. Perhaps it is catching because I felt the same way about Cheshunt. The two towns are after all very close together. The northern extremity of Walthan Cross almost reaches the southern extremity of Cheshunt, so the rail journey between the two places should only take a very short time. Cheshunt Station is in a pleasant place on the eastern side of the town and adjoins the River Lee Country Park.

The photograph is of a fountain located on a traffic island in the centre of the town. It is a feature of what is known as the Old Pond and as can be seen no water was flowing at the time of my visit. One of the friendly citizens mentioned above told me that it is liked by the people of the town. At times it is floodlit and it features reindeers around it at Christmas.

The 2011 census put the population of Cheshunt at 45,832 but it is now more like 53,000. It has a lot of history and there is much that can be said about the place. In the early days it was a settlement on Ermine Street, the main Roman road leading north from London. In 1086 the Domesday Book recorded it as 'Cestrehunt', the name referring to a castle erected by the Romans. It also mentions that it had a priest. The present St Mary's Church is Grade I listed and was built between 1418 and 1448.

One of the town's distinctions is that it is the location of the world's first passenger-carrying monorail. It was horse-drawn and 0.75 miles long. It started operating in 1825 and ran from the High Street to the River Lea.

A very sad event occurred on 12 August 1944. An American B-24 Liberator bomber from RAF Wendling was on a bombing mission and fully loaded with explosives. Following what is described as a mid-air incident the pilot managed to avoid coming down on the town and instead crashed the plane in a field just outside. There was a mighty explosion that would have devasted the town. The pilot, Lieutenant Ellis, and the other nine members of the crew were killed.

Cheshunt did not forget. On the fiftieth anniversary of the end of the Second World War a section of the B198 road, which was close to the crash site, was renamed Lieutenant Ellis Way. Some time afterwards a memorial listing the names of the dead airmen was placed close to where the plane came down. It was later vandalised and moved to a safe place. How sad! How very sad!

For a town of its moderate size it is remarkable that Cheshunt had close connections with two major British companies – Tesco and Lotus Cars. Tesco was and is a major supermarket chain and one of the world's largest retailers. For many years it had its headquarters in the town. Following a year's poor trading this ended in 2015. The company slimmed down the number of its head office employees and moved it to nearby Welwyn Garden City.

Lotus is a name that will be instantly familiar to devotees of motor racing. Colin Chapman brought his group of companies, including Lotus Cars and Team Lotus, from Hornsey to Cheshunt in 1959. Lotus won no fewer than seven constructor championships and two of these triumphs were achieved in 1963 and 1965 when it was based in the town. It also won six Drivers Championships and the Indianapolis 500. In time the needs of the company outgrew the premises and in 1966 Chapman took it to Hethel in Norfolk. He died in 1982 at the age of only fifty-four. Shortly afterwards it was discovered that he had participated in a major fraud, which would almost certainly have led to a long prison sentence.

Cheshunt is still only a medium-sized town, but a remarkably large number of famous people have lived in it or been closely associated with it. The following are five of them:

Richard Cromwell
He was briefly Lord Protector for nine months in 1658/59. He was the son of Oliver Cromwell and died in Cheshunt.

King James I
This is James I of England and VI of Scotland. Among other things he is noted for the glorious King James Bible being named after him. He lived in Cheshunt in his later life and died at Theobalds Palace at the edge of the town.

Laura Kenny
Her many cycling achievements include five Olympic gold medals. She was born in Cheshunt.

The old pond.

Sir Cliff Richard
He has been an active singer since 1957 and has sold more than 250 million records. He lived in Cheshunt and went to school there for seven years, starting in 1950.

Cardinal Wolsey
He was given land in Cheshunt by King Henry VIII. Cheshunt Great House was owned by the Cardinal for ten years from 1519 to 1529.

Other famous people with connections to the town include Queen Elizabeth I (a regular visitor in her early years), Victoria Beckham (singer and fashion designer), Michael Dobbs (writer and politician), Linda Lusardi (former glamour model and actress) and Billy Joe Saunders (boxer).

Roydon Marina Village

Roydon Marina Village is 6 miles beyond Cheshunt and shortly before Harlow. It is on the left side of the train immediately after Roydon Station. The first part to catch the eye will be an area containing a considerable number of lodges. Then it will be a large expanse of water containing many boats. This is the marina.

The lodges are for sale or hire. I have not been inside any of them but during a walk around I was favourably impressed. I did not see many people but those that I did see all seemed to be enjoying themselves. As well as the lodges, the site includes a hotel and a separate restaurant.

It is not far from the village of Roydon, where St Peter's Church and the village centre are Grade I listed. Visitors who are historically minded will be interested to know that Roydon Hall, which was demolished in 1864, was acquired by Henry VIII in 1531. In the following year he gave it to Anne Boleyn who became his second wife and queen in 1533. Anne was not alone in finding that marrying Henry was not a good career move. She was beheaded three years later. More adventurous visitors may fancy a visit to Rye House Kart Raceway, which is not far away. This is well known and Lewis Hamilton is just one of the Formula 1 stars who raced there in their early years.

The marina, which covers 32 acres, is shown in the photograph. I rather naively decided to count the boats in it, but it was difficult and I abandoned the attempt. Afterwards I thought that it was rather sad pointer to my background as an accountant. I was always good at counting stock. Let us just say that the boats were numerous and that they all appeared to be well maintained. The access to the marina is from the River Stort and via this the boats can join the River Lea and the canal system.

I was fortunate that my visit was on a beautiful summer day and could not help but be impressed by the beauty of the water and the boats. As a person who enjoys country walks and lovely countryside I was inspired by the surroundings and the possibilities of strolls and hikes.

The Marina.

Sawbridgeworth

Sawbridgeworth is 4 miles beyond Harlow and 4 miles before Bishops Stortford. It can be classed as a large village or small town, probably a small town, and is another very pleasant place. Like Waltham Cross and Cheshunt it has an interesting history. Like them it was mentioned in the Domesday Book of 1086. The name given to it then was

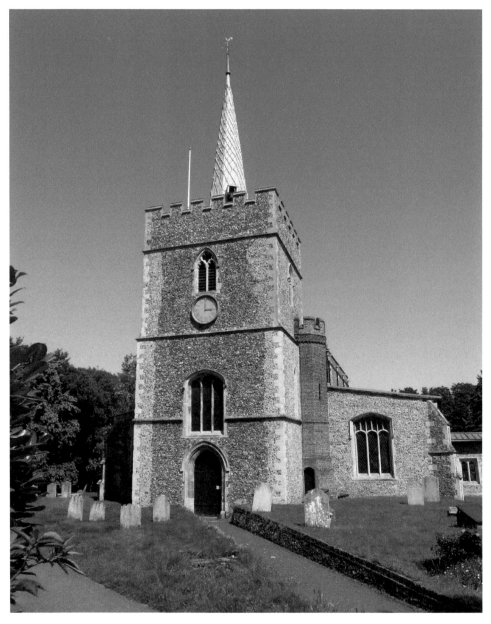

Great St Mary's Church.

'Sabrixteworde'. Like Roydon, mentioned in the last chapter, it has a connection with Anne Boleyn. Pishobury Estate was given to her by Henry VIII. She did not live long to enjoy it.

Sawbridgeworth Station is on the eastern side of the town and immediately following a level crossing. It cannot be seen from the train but the River Stort at this point is close to the track on the left side, and runs parallel with it. One can tell when the train is close to the station because the Maltings can be seen just beyond the car park on the left side. They are a long row of rather attractive-looking brown buildings.

Quite a bit of the town's earlier prosperity was derived from the Maltings. They now contain businesses of various types including cafés, but having said that they are especially noted for antiques centres. A person with a taste for that sort of thing could well spend several hours in the different premises, perhaps interspersed with visits to one or more of the cafés.

Much of the town centre is a conservation area and many of the buildings date from the Tudor, Stuart and Georgian periods. The first Tudor monarch was Henry VII, who came to the throne in 1485. The last Georgian monarch was George IV, who died in 1830. Despite commissioning the Royal Pavilion in Brighton he was not a man respected by most of his subjects. *The Times* obituary commenced with the words 'There never was an individual less regretted by his fellow creatures than this deceased king. What eye has wept for him? What heart has heaved one throb of unmercenary sorrow?'

The photograph is of Great St Mary's Church, which is Grade I listed. The reason for the inclusion of the word Great in the name is not known, but it is probably to distinguish it from St Mary's Church in relatively nearby Gilston. Let us hope that the people of Gilston are not offended.

The earliest part of the building dates back to the thirteenth century but there was probably an earlier Saxon church at the same place. The church has a Tudor tower with a clock bell from 1644. There are eight ringing bells with the two oldest dating from 1749. It contains many fine monuments and brass engravings. The images include Ralph Jocelyn, who in the fifteenth century was twice Lord Mayor of London, members of his family and other locally notable people. The brass engravings are greatly appreciated by the people who enjoy brass rubbing.

One of the monuments honours Corporal Joseph Vick who is buried in the churchyard. He took part in the Charge of the Light Brigade at Balaclava in 1854. He was wounded in the head and his horse was killed from under him. Tennyson's epic poem has it that the noble 600 took part in the charge. More reliable estimate put the number at 670, of which 118 were killed and 127 wounded.

Church history is interesting but it should be mentioned that the church's website and other indicators show that it is very active today. Many churches are not in a position to say that.

Thorley Wash Nature Reserve

The Thorley Wash Nature Reserve is approximately 4 miles beyond Sawbridgeworth and shortly before Bishop's Stortford. It is on the right side of the train. It is long and narrow and it extends for nearly a mile. For all of this way it is right next to the line or very close. The photograph includes a passing train and was taken from a point on the reserve.

Crossways away from the line the reserve extends to the River Stort. At this point the river forms the border between Hertfordshire and Essex.

The reserve covers an area of 17.3 hectares, which for those who prefer imperial measurements is 42.7 acres. It was formerly the Thorley Flood Pound and acted in this capacity until it was decommissioned from this purpose in 2004. The area was purchased from the Environment Agency in 2011 by the Herts and Middlesex Wildlife Trust. It is now a Site of Special Scientific Interest and managed by the Trust.

The reserve can be described as fen habitat. For various reasons the number of these in Britain have declined enormously. That makes this one especially important and is a reason to thank and congratulate the Herts and Middlesex Trust for the valuable work that it has done.

Accounts of the birds, insects and wildflowers that may sometimes or always be found there include many names with which I am not familiar. Although I know some, this points to lamentable gaps in my knowledge. Let us start with wildflowers. They include ragged robin, marsh marigold, fen bedstraw, cuckoo flower and marsh orchids. The many insects include branded demoiselle and broad-bodied chaser.

Birds include whitethroat, blackcap wren, snipe (in the winter months), goldfinch, siskin, redpoll, grasshopper warbler, Cetti's warbler, barn owl and cuckoo. If the rhyme is to be believed the last of these should be sought in the spring or early summer. We all learned

The cuckoo comes in April,
It sings its song in May,
It lays its eggs in June,
And in July it flies away.

A train at the edge of the reserve.

The Trust is particularly pleased with its success, starting in 2015, with the introduction of water vole. This species has declined greatly in Britain for a number of reasons, mink and the pressure on their habitat being two of them. They are shy and shun human contact. Observation of them is most likely to be successful in the summer following the breeding season.

As was true with London's Windmill Theatre during the war the reserve never closes. There is no motor vehicle access – the nearest point for cars being Spellbrook Road East. This is off the A1184 road south of Bishop's Stortford. It is necessary to cross the railway line to get to the right place. The postcode for stopping is CM22 7SE.

To gain access by foot it is necessary to walk for nearly half a mile northwards along the towpath of the River Stort. The starting point is a lock next to the road. After this a footbridge over the river is crossed and this leads directly into the reserve. During my visit I did not see a single person, either by the river or in the nature reserve. It was a peaceful, educational and enjoyable experience.

Bishop's Stortford

The pleasant town of Bishop's Stortford has a population slightly in excess of 40,000 and is reached shortly after the Thorley Wash Nature Reserve. Its history dates back to before the Norman Conquest in 1066.

How the town got its name is interesting. It seems reasonable to assume that there was a ford over the River Stort and that the area was owned either by a bishop or a man called Bishop. This is only partly the case. A Saxon settlement was named *Steort-ford*, which means the ford at the tongue of land. In 1060 the Bishop of London bought Stortford Manor. The river was later named after the settlement, not the other way round. We have to give our forebears credit for their mastery of grammar. The use of the apostrophe is appropriate.

At the time of the Domesday book in 1086 the population was around 120. Soon afterwards a Saxon or Norman wooden fortress was converted to a masonry structure. It was given the name Waytemore Castle. It was a motte (mound) and bailey (courtyard) construction. The mound was surrounded by a moat and the top of the mound was protected by a curtain wall of flint and rubble. The castle was rebuilt with stone in the first half of the twelfth century. It came under religious control and was seized by King John in 1208. He was in dispute with the Pope at the time and demolished the castle. He was later reconciled with the Pontiff and rebuilt it at his own expense. Over the following centuries it fell into a ruined state. All that remains is the mound and the foundations of a tower. The photograph is of the mound. It is not far from the railway line but cannot be seen from the train.

Like most parts of Britain, Bishop's Stortford suffered from the Covid pandemic, but it is classed among the country's more prosperous areas. One of the reasons for this is its vicinity to Stansted Airport, which is only a few miles away. The rail link to the airport joins the London to Cambridge line just a few miles north of the town. Airports tend to increase prosperity in nearby areas. Bishop's Stortford's shops and town centre retain a certain degree of charm and there is attractive residential property by the river and elsewhere.

Over many years the town has been proud of its low crime rate, but nevertheless there have been two major criminal outrages that sullied this reputation. The first was in 1825 when a number of buildings were the object of arson attacks. The damage was extensive and

much alarm was generated. A committee was formed and a very large reward offered for information leading to the identity of the perpetrator. At the same time townspeople were receiving letters saying things like 'Stortford shall be laid to ashes'. A Mr Thomas Rees was found guilty of sending the letters but not of starting the fires. He was transported to Australia.

The other outrage was relatively recent and took place in 2007. It was a triple murder and a double attempted murder. They were revenge attacks by two young drug dealers on other drug dealers who they believed had supplied them with poor-quality cocaine. The two young men, who were brothers, went to a house where the other group was. Armed with a machine gun, one of them shot and killed three men and the family dog. A fourth man escaped by hiding in the garden. There were no more bullets but two women were targeted with a knife. They were injured but both survived. One of the women was shielding a three-year-old child who was unhurt.

One of the attackers was sentenced to serve forty-two years in prison and his brother also received a long sentence. Other people who did not go to the house were sentenced to terms of imprisonment for assisting an offender. Crimes do not come much worse than this – and so untypical of the seemingly peaceful town.

The castle's surviving mound.

The spire of St Michael's Church extends from a tower. It is elegant, thin, pointed and to my mind very attractive. The church is located on high ground and the spire is clearly visible throughout the town. An early Norman church fell into disrepair and work on the present building commenced in the early 1400s. The church has a long and interesting history and it remains a vibrant servant of the faithful and of the community. Unlike most saints Michael is not human. He is an archangel who features in the Book of Revelation.

Francis Rhodes was the vicar of St Michael's from 1849 to 1876. His fifth son, Cecil, was born in the town and he achieved a vast amount of wealth, power and fame, though some would use the word notoriety. He attended Bishop's Stortford Grammar School and is the most famous person associated with the town. Cecil was a sickly child and when he was seventeen his father sent him to South Africa because he thought that the climate would be good for his health.

Cecil entered the diamond trade at the age of eighteen and he became very rich very quickly. His company, De Beers, became dominant in the business and has remained strong right through into the twenty-first century.

Rhodes was fiercely British and fiercely imperialistic. He was Prime Minister of Cape Colony for six years and he played a major role in founding Rhodesia, which was named after him. This is now the independent countries of Zimbabwe and Zambia. He pursued an imperialistic dream of a railway from Cairo to the Cape running exclusively through British-controlled territory. This nearly but not quite happened.

His behaviour towards the black people of Africa is debated, though many view it unfavourably or even very unfavourably. He should perhaps be judged by the standards of his time. Also, he genuinely believed that Britain was the greatest and most enlightened country in the world. He thought that the expansion of British territory and influence was in the interests of other people and races as well as those of Britain.

Rhodes suffered from poor health throughout his life and he died at the age of only forty-eight. His will left a very large sum of money to fund Rhodes Scholarships at Oxford University. The former American President, Bill Clinton, was just one of the many subsequent Rhodes Scholars. Rhodes' birthplace was established in 1938 as the Rhodes Memorial Museum. It is now known as the Bishop's Stortford Museum. At the time of writing a vociferous campaign to remove Rhode's statue from Oriel College, Oxford, has not succeeded. There has not been a campaign to stop taking advantage of the money that he left. Should Bishop's Stortford regard Cecil Rhodes as its greatest son? Views differ but many think not.

Mountfitchet Castle and the House on the Hill Toy Museum

The village of Stansted Mountfitchet is just over 3 miles beyond Bishop's Stortford. The name of the nearby Stansted Airport is taken from the first word. Whoever made the decision to drop Mountfitchet from the airport's name was surely wise. It would otherwise have been complicated and had five syllables.

Mountfitchet Castle is in the village very shortly after the station. It is on a hill close to the left side of the train and can be seen by looking over a car park. The photograph was taken from a point adjacent to the track.

The castle and village are, of course, not original and they opened to the public in 1985. They are imaginative reconstructions of the castle and village that at one time existed on the exact spot. The site once housed an Iron Age hill fort. Later there was a Roman signals fort, then Saxon and Viking settlements. In 1066 it was taken by the Norman army of William the Conqueror. Robert Gernon, who may have been related to William, built the motte-and-bailey castle on the hill. The male line of the Gernon family only lasted for five generations. Robert's son (the second generation) dropped his surname and adopted the name Mountfitchet. This was used by his descendants.

Richard Mountfitchet (the fourth generation) died in 1203 leaving his son Richard Mountfitchet II (the fifth generation) as a ward of King John. In 1211 this changed and he became a ward of his mother. As soon as he became of age he joined the opposition of many of the barons to the rule of King John. The fortunes of the king waxed and waned, but at a time when they were waxing he destroyed the castles of many of the barons who opposed him. Mountfitchet was one of them.

As every British schoolchild should know, in 1215 the barons met John at Runnymede and forced him to seal Magna Carta. This reduced the power of the king, but it did not give it to all the people. It was 1918 before all adult men got the vote and 1928 before all adult women did so. It did, though, give more power to the barons.

Despite his great youth Richard was one of twenty-five barons chosen to enforce the provisions of Magna Carta. Later he regained the monarch's favour under Henry III and his estates were restored to him, and these included Mountfitchet Castle. He never married and had no children (at least no legitimate ones) and when he died his estates passed to his three sisters. The castle remained in deteriorating ruins until its reconstruction late in the twentieth century.

The photograph shows the wooden palisade round the castle and village. The reconstruction of everything inside is an educated attempt to make everything as it would have been in 1086 or soon after. It is described as an open-air museum. All of it is intended to have educational value and to appeal to children as well as to adults. It is the only medieval castle and Norman village reconstructed in its original site anywhere in the world.

There are a total of twenty buildings and artefacts on the site and they include a church. I have seen a very plausible suggestion that the priest would have been the only literate person. However, I believe that the baron and his male descendants would have been exceptions to this. I do not know enough to speculate about female members of his family. The baron and his family would have worshipped at the front and everyone else at the back. This is the origin of the saying 'the weak go to the wall.'

Defensive structures feature. There are a number of watch towers and what is described as a siege tower. There are two mangonels. My reference book says that a mangonel, also called a traction trebuchet, was a type of trebuchet or siege engine. The mangonel was replaced as the primary siege weapon in the twelfth and thirteenth centuries by the counterweight trebuchet. The purpose of a mangonel is to hurl a heavy object a long way. The ones at Mountfitchet are capable of catapulting a 56-pound weight more than 200 yards. I do not suppose that they are ever tested, but if they are great care must be exercised. The railway is within range.

Wooden palisade.

There are two ponds. One would have been for eels and one for carp. Animals and birds that would have been there at the time roam freely and can be approached by visitors. They include fallow deer, sheep, goats and chickens.

We have a chicken to thank for a remarkable find. It was scratching about and unearthed a very interesting object. This was seen by a visitor and was handed to a member of staff. The find turned out to be a rowel, which was part of a spur worn by knights a thousand years ago. There have been a number of other interesting finds, though none of them involving chickens. One was a Norman brooch unearthed by workers repairing some steps.

To my mind at least one of the features could be disturbing, especially for children. There is a mock body hanging from a tree. The death penalty was not abolished in Great Britain until 1965, though the last execution was in 1964. It survived longer in Northern Ireland but the last execution there was in 1961. However, in the latter years executions were few and far between. This was not the case in Norman times and there were no Home Secretaries to consider a reprieve. Interestingly, the tree from which the mock body is hanging is said to be between 600 and 900 years old. The castle is a Grade II listed National Historic Monument.

The House on the Hill Toy Museum is within the grounds of the village and there is no extra charge for going in. A ticket for Mountfitchet Castle allows entry. The writer requests your indulgence for the rest of this chapter. It contains a number of personal reminiscences and views.

A very good booklet about the toy museum states that it is the largest privately owned toy museum in Europe. However, Mountfitchet Castle's website says that it is the largest in the world. What is the explanation for the discrepancy? The booklet was published in the late 1990s so the collection has probably grown bigger since then. Alternatively and very fancifully, have one or more privately owned toy museums outside Europe closed or reduced in size? In any case how can they possibly know it is the biggest? Whatever! It is certainly big and impressive.

The toys date back to the late Victorian period. The contents are, or were, based on the collection of Alan Goldsmith, who started by buying a Hornby train set in 1946. At the time of the booklet's publication he and his son, Jeremy, were the owners and curators of the museum.

I was immediately attracted to the name Hornby, which featured prominently in my childhood. Frank Hornby was born in 1868 and in 1907 he invented Meccano. In 1915 he and his company started making clockwork trains, with ancillaries such as signals and bridges. As a child I spent many happy hours playing with my meccano set and clockwork Hornby train. I never managed to acquire any of the company's diecast electric trains. I did, though, enjoy playing with one owned by a friend. I did have a number of dinky toys, which were a spin-off from Hornby.

Sections of the museum are, among others, devoted to toy soldiers and other military toys, dolls, board games and teddy bears. I was particularly pleased to see old children's annuals (books) such as an early one for Rupert the Bear. He was a childhood hero of mine.

A thought relates to the monetary value of some old toys and books, and of course to some other objects as well. I pondered about what I have discarded over the years and what their value would be now had I kept them. A downside would have been that my loft would be even more cluttered than it is already. As you probably know early toys and other things in good condition (or best of all in mint condition) are the most likely to have a high monetary value.

In conclusion would I recommend a visit to the castle and the toy museum? The answer is yes I would.

Elsenham and its Connection to Horses

The village of Elsenham is 6 miles beyond Bishop's Stortford and reached shortly after Stansted Mountfitchet. Its railway station was opened as far back as 1845. Elsenham is not large (population less than 4,000) and it would have been much smaller then. One wonders how such a small village justified having its own station. It illustrates just how much the coming of the railways transformed the country around this time.

I was in a good mood during my visit and perhaps this is part of the reason why I found the station pleasing. The up and down platforms are on either side of a level crossing and the line can be crossed either at ground level or by a footbridge. I spent a happy half hour in a café immediately adjoining the platform serving the line to Cambridge and am indebted to the lady running it. She provided some of the information in this chapter and she served very appealing cakes too.

Pleasant as the station is there have been two tragedies in the not so distant past. The footbridge was only erected in 2007 and in 1989 a passenger crossing the tracks on foot was struck and killed by a fast train not stopping at the station. Two teenage girls were killed in similar circumstances in 2005. Red lights were flashing and a Klaxon was sounding at the time, but it is believed that the girls thought they were warning of a train arriving at the opposite platform. At the time the passenger crossing gates were manually operated and the curvature of the track meant that the oncoming through trains were only visible for a very short time.

Following the second accident Network Rail was prosecuted and fined £1 million, and in 2007 locking gates were introduced at the foot crossing. The accident led to review by the Rail Accident Investigation Branch of all pedestrian level crossings at Britain's stations. We are all safer as a consequence.

Like many of the towns and villages close to the line Elsenham's origins pre-date the Norman Conquest in 1066. The 1086 Domesday Book records that part of the village belonged to Robert Gernon. He was the baron responsible for building Mountfitchet Castle, which is the subject of the previous chapter.

Many would say that Elsenham's most notable feature is the large pump house in the High Street and a photograph of it appears in this chapter. It was erected in 1896 by Sir Walter Gilbey as a memorial to his late wife, who had died earlier in the year. It was built over the village well and the depth of the well was extended. The structure has round brick sides and oak posts supporting a gilded dome. The pump house is large and the dome, which is now green, was originally covered in gold leaf. I have read that it was covered in the Second World War because it might have been a navigation assistance to German bomber crews. Given its size this notion seems fanciful but perhaps it is true.

Sir Walter Gilbey was a prominent member of his family's business as wine merchants. They also had whisky distilleries and were the proprietors of Gilbey's Gin. In addition, Sir Walter was a philanthropist and a very well-known breeder of shire horses – the first mention of horses in this chapter. He was a well-known authority on the subject and published several books. Among other things he was President of the Royal Agricultural Society and on a number of occasions welcomed his friend the then Prince of Wales as a visitor to his mansion, Elsenham Hall.

The Pump House.

In 1889 Sir Walter founded the company that made Elsenham Jam, using fruit grown on his own estate. At one time the product was marketed as 'the most expensive jam in the world'. This was a marketing tactic not an apology, but it seems hard to think of a slogan less likely to secure sales. However, the company had some success. Perhaps it implies exceptional quality and buyers found the prospect attractive. Elsenham Jam is still produced but it is no longer made in the village.

The other photograph is of a gold-plated mailbox and this is the chapter's second link to horses. The box is located at the end of Station Road not far from Elsenham Station.

In a very imaginative step in 2012 Royal Mail painted a mailbox gold in the city, town or village closely associated with each of Britain's gold medal winners at the London Summer Olympics and London Paralympics. Elsenham's gold box celebrates the medal of Ben Maher for his team showjumping success. Due to a misunderstanding a nearby town nearly got the honour instead. The reason was that Bishop's Stortford is part of Elsenham's postal address.

Maher, who was born in 1983, has had a great number of successes in various showjumping events over the years, and for this reason the chapter could be much longer. His triumphs include an individual gold medal at the Tokyo Summer Olympics in 2021. Could the story get better still? Yes it could. Ben married his fiancée just two weeks after winning his second gold medal. August 2021 was a busy and eventful month for him.

Ben Maher operates from Elsenham Stud Farm and his 2021 Olympic-winning horse, Explosion W, was stabled there. The stud farm counts as Elsenham's third link to horses. It is very much in business now, as Maher's showjumping activities illustrate, but many people find it interesting for a different reason. The horse Golden Miller, a bay gelding, is buried there. In many people's opinion it ranks with Red Rum as the greatest ever horse over jumps. The Grand National and the Cheltenham Gold Cup are Britain's premier steeplechases, with the Grand National generally ranking first. Golden Miller's record in the Cheltenham Gold Cup was:

1932	First place at odds of 13/2
1933	First place – favourite at odds 4/7 on
1934	First place – favourite at odds 6/5
1935	First place – favourite at odds 1/2 on
1936	First place – favourite at odds 21/20
1937	Race not held due to bad weather
1938	Second place

It is worth noting the very short odds in four of the races. They are less likely in jump races than in flat races. This is because of the risk of falling, perhaps through little or no fault of either the horse or the jockey.

In the middle of all this success Golden Miller won the 1934 Grand National in a time that took more than eight seconds off the then record. It remains the only time that a horse has won the Cheltenham Gold Cup and the Grand National in the same year. This followed a Grand National run in the previous year when he fell at the Canal Turn on the second circuit. He was closing on the leaders when it happened.

Golden Miller was born in Ireland in April 1927 and neither his sire nor his dam had ever won a race. He was sold as a yearling for £100, then as a three year old for £1,000. A year later he was sold to the Honourable Dorothy Paget. The price was £12,000 for a two-horse deal.

If we were being kind, we would call the lady idiosyncratic, but if not one would say that she was difficult. If we were being very unkind we would say she was very annoying.

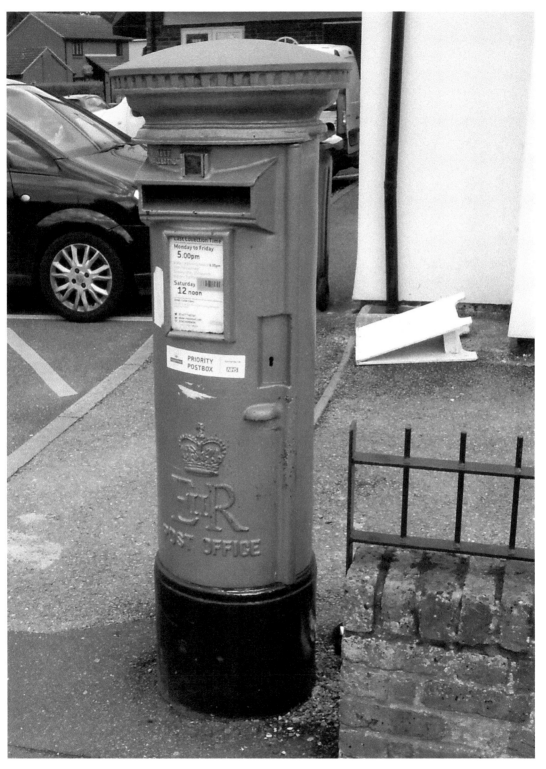

The gold post box.

Her many eccentricities included, when she had no daytime arrangements, having her breakfast at 6.30 p.m., then setting about what was her day. She had no compunction about ringing her trainers and others during what was her day but their night. She was very rich and she paid a lot of money for Golden Miller. She did, though, get an outstanding bargain.

The Elsenham Stud Farm is on the right side of the track at Fullers End, shortly before Elsenham Station. Unfortunately it cannot be seen from the train. This is because of a cutting and nearby trees. It is what the Tottenham chapter in this book calls geometric frustration.

Audley End

This chapter is mainly about Audley End House and Gardens, which is appropriate because of their age, size, history, beauty and present attractions. The house dates back to 1605 and the place has a history before then. The surrounding area and the station are named after it, not the other way round.

The station is just over 41 miles from London, Liverpool Street, beyond Elsenham and between the stations of Newport and Great Chesterford. It was opened in 1845 and is close to the small town of Saffron Walden. Starting in 1865 there was a branch line between the two places, but it was closed in 1964. Like so many lines of its type it was a victim of the so-called Beeching cuts.

The origin of the house was a Benedictine priory founded by the 1st Earl of Essex in 1139. This became Walden Abbey in 1190 and it remained as such until 1538 when it was suppressed by Henry VIII. He then granted it to his Lord Chancellor, Thomas Audley. This was the man from whom the building's name and indirectly the name of the station was derived. By the time of his death in 1544 Audley had been created Baron Audley of Walden and he had converted the property into a mansion.

Ownership passed to Thomas Howard, 4th Duke of Norfolk, who was executed in 1572. His offence was conspiring with Mary Queen of Scots against Elizabeth I. The duke's second son afterwards managed to gain Elizabeth's confidence and was created Baron Howard de Walden. James I (James VI of Scotland) came to the throne in 1603 and made him Baron Howard, Earl of Suffolk and Lord Chamberlain.

In 1614 the earl was made Lord Treasurer, but four years later he was convicted of corruption, extortion and bribery. Much of the money that he had acquired in this way had been spent on the extensive rebuilding of Audley House. Surprisingly, we may think, his only punishment was a fine and he was allowed to retire there in impoverished disgrace. Audley House could by then be described as almost a palace and it included royal apartments for the King and Queen. King James visited twice in 1614.

The fine left Howard's successors seriously in debt, but their situation improved in 1670 when Charles II bought the house and the estate from them. However, part of the debts were left mortgaged. One of the attractions to the king was the proximity of the property to Newmarket. He loved horse racing. The Suffolk family were allowed to reside in part of the building and they were charged with looking after it. Despite this the house deteriorated and in 1701 it was returned to the heirs of the earl in settlement of the mortgage.

In the early 1700s the size of the house was successively reduced and in 1745 the estate was divided among the Howard family. Six years later the Countess of Portsmouth, who

was part of the family and best placed financially, bought the house and park to add to her inherited part of the estate. In 1762 it passed to her nephew Sir John Griffin.

Sir John, who had the means to do so, employed the celebrated architect Robert Adam to enlarge and improve the house. He also employed the landscape architect Lancelot Brown, commonly known as 'Capability Brown', to remodel the rather formal landscape. Sir John took a keen interest in the work and at a late stage he fell out very badly with Brown. The quarrel was mainly over responsibility for the cost overrun, but also because Brown had departed from the original plan by diverting the widened River Cam in a direction different from the one agreed. A different architect finished the work but the finished job was still very much a Brown project.

Brown was certainly very capable but this was not the reason that he acquired the sobriquet by which he was almost universally known. It was because when he was called to give an opinion he would usually respond by saying that the landscape was capable of improvement. He is often regarded as Britain's greatest ever landscape architect. He was renowned for moving away from formal layouts and was responsible for remodelling Blenheim Palace, Stowe, Warwick Castle and more than 200 other places. Despite all this his work was not always without criticism. A contemporary once remarked that he hoped to die before Brown because he wanted to see heaven before it was improved.

In 1784 George III recognised Sir John Griffin's claim to the Barony of Howard de Walden and this inspired him to set about having the house further enlarged and further improved. Howard was a competent amateur architect and his second wife was a competent decorator, and they planned much of the work themselves. They also added to the house's contents, and improved and extended the park.

Howard died in 1797 and the property passed to a descendent of Lady Portsmouth's first husband. This man became the 3rd Baron Braybrooke in 1825. At this time he commenced the last set of major changes to the house, his aim being to reinstate its Jacobean character. He also restored some of the eighteenth-century character of the gardens. What would Capability Brown have thought?

Audley End then passed down several generations of Braybrookes. The 7th Baron sold his seat in Berkshire and brought its contents to it. In 1941 it was requisitioned for war use and it served as the headquarters of the Polish Section of the Special Operations Executive. In 1948 it was bought for the nation. The 9th Baron Braybrooke left many of the house's contents on loan. It was initially managed by the Ministry of Works but this was later changed to English Heritage, which is the position now.

Audley End House and Gardens can be visited by the public. English Heritage's Audley End website summaries the experience that can be expected as follows:

> Enjoy a day out exploring the spacious grounds and estate of one of England's grandest mansions, Audley End. Whether you're exploring the servants' wing, state rooms, stables, kitchen gardens or beautiful grounds, you'll discover what life was like above and below stairs at a Victorian country house.
>
> Wander the glorious state rooms, reflecting the taste of the third Lord Braybrooke who redecorated many of its rooms in the Jacobeam style in the 1820s. Make yourself at home and feel free to play the piano, play with the toys in the nursery or step into Lady Braybrooke's private apartments, lit for her return from an evening party. Explore the Service Wing including historic kitchens, a dairy and laundry rooms to see what life would have been like for the Victorian servants that worked here. Take a stroll over to the stable yard to meet the horses and find out the story of the estate at work and play.

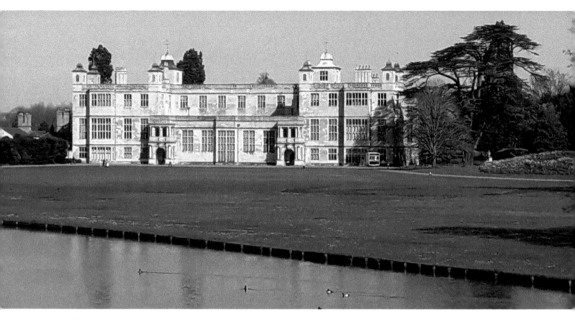

Audley End House.

Wander the award-winning gardens remodelled by Capability Brown. Marvel at the formal beautifully restored parterre and cloud hedge before admiring the organic kitchen garden. Wander through the acres of parkland to discover the peaceful Elysian Garden, Temple of Concord and memorial to the second World War Polish resistance soldiers.

I must confess that I was not familiar with the word 'parterre'. It is a level space in a garden occupied in an ornamental arrangement of flower beds. To use the phrase wrongly attributed to Sir Michael Caine, not a lot of people know that.

The railway line from London to Cambridge is not the only one running through Audley End. The Audley End Miniature Railway is a 1.5-mile-long ride through woodlands on the Audley End Estate. It starts directly opposite Audley End House and the route crosses the River Cam. It is possible that peacocks might be seen. Some of the rides are hauled by steam engines and some by diesel engines.

The rides and site very much cater for young children. Teddy bears and teddy bear house can be seen as can fairies and elves. There is a café and a children's adventure play area. There are special events and special trains run at such occasions as Christmas and Halloween.

Duxford Chapel at Whittlesford

The village of Whittlesford is 7 miles south of Cambridge and it is served by Whittlesford Parkway Station. It is close to the villages of Sawston and Duxford, which houses the Imperial War Museum.

Duxford Chapel.

Duxford is in the name of the chapel that is the subject of this chapter. It can easily be seen from the train. The chapel is about 80 yards away and in Station Road on the right-hand side. It is at right angles to the line so it is an end that directly faces the track. There is a Holiday Inn hotel adjoining part of the station and it is necessary to pass it then look slightly backwards.

It was once part of the medieval Hospital of St John, which was founded by William de Colville in the early thirteenth century. Very little is known about this, which is a pity. The chapel was built about a hundred years later. So it is around 700 years old, which is impressive. Some sections are believed to date from a predecessor building that formed part of the hospital. It is Grade II listed and a Scheduled Ancient Monument.

The chapel is a single-storey building and was built using flint rubble for the walls and limestone for the doorways and windows. The exterior of the east window still has evidence of elegant tracery. The other windows are early fourteenth century in style with an unusual cusped design. In one of them slots for glazing bars and glass can be seen. Historic plaster survives on some of the walls.

The chapel was suppressed during the dissolution of chantries during the short reign of the youthful Edward VI. I had to check the meaning of the word chantry and discovered that it is an endowment for the singing of masses for the soul of the founder. Alternatively it is a chapel or altar so endowed.

After the Second World War the chapel passed into the control of the Ministry of Works and in the period to 1954 there was a programme of restoration. It is now in the guardianship of English Heritage.

Entry to the chapel is free and it is open at nearly all times. It is not large and it is empty inside, so inspection is not likely to take long, but a visit is worthwhile.

Cambridge

The attractive village of Grantchester is close to the line and almost adjoins the city of Cambridge. However, it cannot be seen from the train, which is a pity. Its distinctions include the claim that it houses the world's highest concentration of Nobel Prize winners, which for a village seems extraordinary. How do they know? Whatever! There are quite a few. Most or all of them would have past or present connections with the University of Cambridge.

The Old Vicarage in Grantchester is now the property of Lord Jeffrey Archer and his distinguished wife Mary, and it was once the home of the poet Rupert Brooke. It was made famous by him in his poem 'The Old Vicarage, Grantchester', written in Berlin in 1912. The fondly remembered last two lines reflect the fact that the hands on the church clock had not moved for a very long time:

> Stands the church clock at ten to three?
> And is there honey still for tea?

It reminds one of the irrelevant details inserted by Lord Haw Haw (William Joyce) into his wartime broadcasts to Britain from Nazi Germany. His 'facts', which were often wrong, were inserted to try and make his listeners believe that spies were reporting information to Germany.

Cambridge Station is 55 miles from London Liverpool Street and it is the thirteenth busiest UK station outside London. Furthermore, one of its platforms is 514 yards (470 metres) long, which makes it the third longest station platform in the UK outside London. Only ones at Colchester and Gloucester are longer. Having stood at the end of it I can confirm that the length seems overwhelming. It is not a good place to be if you are catching a train at the other end. To put it in context Usain Bolt holds the world 100 metres running record in a time of 9.58 seconds. Travelling continuously at that speed it would have taken him forty-five seconds to run the length of the platform.

The station, which was opened in 1845, is pleasing both inside and outside and its building is Grade II listed. A brisk walk from the station to the city centre takes twenty minutes, and again I write from experience. Given the age of the station and the size of Cambridge when it was built this seemed surprising. The reason is that the university did not want students going away too easily.

Oxford and Cambridge are England's most prestigious universities, though many Scots would object if the claim were extended to the whole of the United Kingdom. The two universities are often collectively referred to as Oxbridge. It is never 'Camford' – Oxford always comes first, as it does in the title of this book. Why should this be? And does it matter? It is rather like Lennon and McCartney, Laurel and Hardy and Morecombe and Wise. Ernie Wise is reputed to have said that he did not mind so long as he got half the money, which he did.

Possibly the fact that Oxford was established first has something to do with it. The University of Cambridge's origins were in 1209 when some Oxford scholars went there after the lynching of two of their number. However, Cambridge's Royal Charter was granted by Henry II in 1231. Oxford had to wait until 1248 for theirs. Cambridge is the fifth-oldest university in the world and, after Oxford, it is the second oldest university in the English-speaking world.

Cambridge has thirty-one semi-autonomous colleges. Twenty-nine of them are for both men and women and two of them are for women only. Magdalene was the last all-male college to accept women and this happened in 1972. The first women's college was Girton, which was founded in 1872, but it was not until 1948 that women were allowed to be full members of the university. All the colleges are self-governing institutions and there are a further 150 academic departments, facilities and other institutions.

The university is and has been associated with a stunning list of eminent people. Just a minute's thought brings to mind Sir Isaac Newton, Oliver Cromwell, Stephen Hawking, John Maynard Keynes, Charles Darwin, John Milton, Samuel Pepys and Emma Thompson. There are hundreds more.

At the time of writing 121 affiliates of Cambridge University have been awarded a total of 122 Nobel Prizes. The discrepancy is because Frederick Sanger has been awarded two, in 1958 and 1980. Nobel Prizes have also been awarded to former students.

The first British Prime Minister, who was also the longest serving, was Sir Robert Walpole who was educated at King's College, Cambridge. There have been thirteen more but none recently. Stanley Baldwin was the last and he retired in 1937. By contrast Oxford has provided twenty-eight and eleven of them have held office since 1945 (Attlee, Eden, Macmillan, Home, Wilson, Heath, Thatcher, Blair, Cameron, May and Johnson).

The Footlights Dramatic Club was founded in 1883 and has nurtured many actors, personalities and comedians. The list includes Stephen Fry, Clive James, Clive Anderson, Peter Cook, Eric Idle, Tim Brooke-Taylor, Graeme Garden, Douglas Adams and John Cleese.

Some of the colleges and college buildings are very old and they are located relatively close together in the centre of the city. A walk round the appropriate streets can be very rewarding. Peterhouse, founded in 1284, is the oldest. King's College, founded by Henry VI in 1441, ranks highly, as does Trinity Hall, founded by Henry VIII in 1540.

The photograph is a particularly good view of Corpus Christi College. I wish that I could make my lawn look as good. This is the sixth oldest in Cambridge and it was founded in 1352 by the Guild of Corpus Christi and the Guild of the Blessed Virgin Mary.

My wife and I are proud to say that my eldest granddaughter is an undergraduate at Selwyn College. I therefore have a special reason for singling this one out. It was founded in 1882 by the Selwyn Memorial Committee and it was named after George Augustus Selwyn (1809–78). He had been a scholar of St John's College, Cambridge, and he was the first Bishop of New Zealand. He served in that capacity from 1841 to 1868. He was then Bishop of Lichfield until shortly before his death. As well as his ecclesiastical distinction he is noted for having rowed for Cambridge in the first Oxford-Cambridge University Boat Race held in 1829.

There is a very long history of sporting fixtures between Oxford and Cambridge, with Oxford displaying traditional dark blue colours and Cambridge displaying their traditional light blue. Cricket, which has almost always been played at Lord's, was first played in 1827. Rugby Union was first played in 1872. Since 1921 the match has been played at Twickenham.

The first Oxford vs Cambridge Women's Boat Race was held in 1927 and it has been held annually since 1964. A reserve race has been held for the men since 1965 and for the women since 1966. The main men's race has been won eighty-five times by Cambridge and eighty times by Oxford. There was a dead heat in 1877. The great majority of the races have been held on the River Thames between Putney and Mortlake in London. There are always large crowds lining the route.

Corpus Christi College.

This chapter names many of the great and the good with close connections to the University of Cambridge, but of course not everyone will admire them all. To put it mildly Oliver Cromwell is not universally revered in Ireland. Very few indeed will admire the Cambridge spy ring not so far mentioned. They are sometimes referred to as the Cambridge Five and were Guy Burgess, Donald Maclean, Kim Philby, John Cairncross and Anthony Blunt.

All of them were at Cambridge in the 1930s and were recruited by Russian Intelligence. They spied for Russia until the 1950s and did a great deal of damage. Burgess, Maclean and Philby fled to Russia. Cairncross and Blunt were later discovered but not prosecuted. It is sometimes claimed that Blunt had information about some members of the royal family that neither they nor the government wanted to become public knowledge.

The University of Cambridge's contribution to modern business should not be overlooked. In recent years numerous innovative, high-technology companies have been established round the city, and it is still happening. Many have been small or very small, at

least to start with, and quite a few of them have gone on to be successful or very successful. For a very few the words stunningly successful would not be out of place.

As the saying goes success breeds success and the area draws in talent, which has an inflationary effect on property prices in the area. However, brains associated with the university have been a major factor. The area has acquired the colloquial sobriquet Silicon Fen. This is because of its geographical position at the southern end of the Fens region and its similarity to the so-called Silicon Valley near San Francisco. The future seems bright.

Journey's End: Cambridge North

It is reasonable to suppose that an account of the journey from London to Cambridge would stop at Cambridge, which is the subject of the last chapter. However, the train goes a further 3 miles and journey's end is the station of Cambridge North. It is a recent addition to the network and was opened as recently as May 2017. In keeping with many such projects this was later than planned – seventeen months later to be precise.

Cambridge North Station is in Cambridge's northern suburb of Chesterton. It really does roll back the years because it is very close to the site of a Chesterton Station that was closed in 1850. The gap was 167 years. As well as handling trains to and from London Liverpool Street, it handles trains to and from London Kings Cross as well as Ely, Kings Lynn and Norwich. Cross-country trains to and from Birmingham and Stansted pass through it without stopping.

Among other things the station serves nearby science and business parks. One of the names considered for it was Stephen Hawking Science Park.

The station is immediately next to a Novotel and the view of the station's frontage is, to me at least, rather pleasing. It is over an open area that contains two statues. The photograph is of the largest of them, which was put in place in June 2021. It is the work of Matthew Darbyshire who is described on it as the artist, and it is constructed of aluminium, stainless steel and concrete. For reasons that makes sense to him he has given it the title 'Hercules meets Galatea'. A small plaque at the base reads

> Hercules meets Galatea is a
> fictional encounter between two
> Greco-Roman characters that
> explores analogue and digital
> making methods. Challenging
> the myth Galatea's poise
> and digital production imply
> power and perfection over
> Hercules somewhat shakier
> manifestation.

Does that make everything clear? It did not do so for me, but I liked it. I will finish by saying that if you like that sort of thing then you will find that it is the sort of thing that you like.

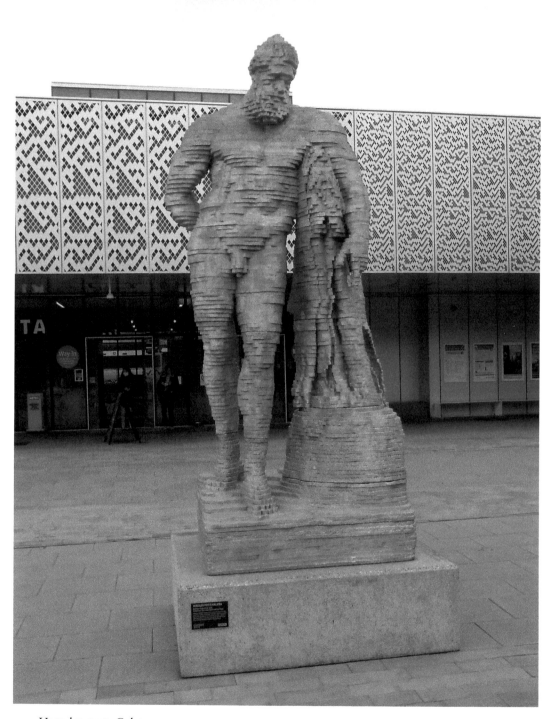

Hercules meets Galatea.